W9-BGP-250

ANCIENT MEXICO

in the British Museum

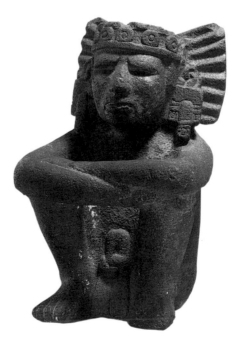

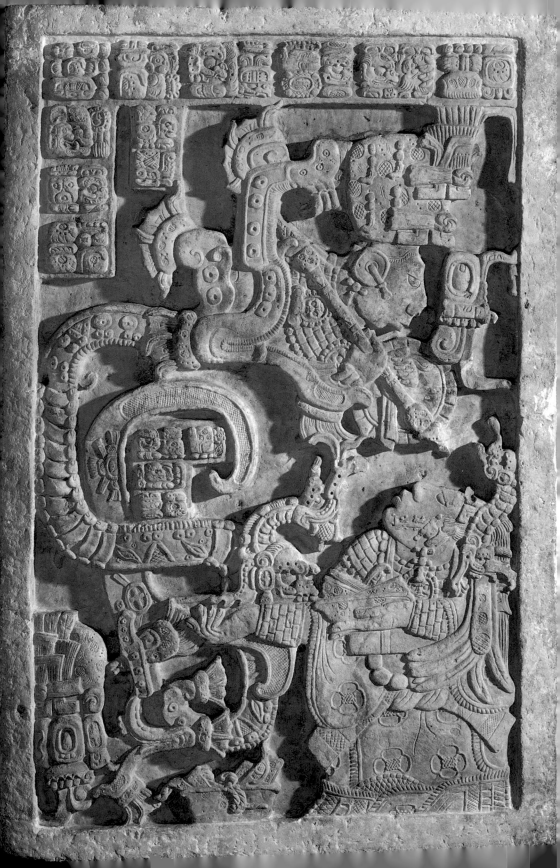

ANCIENT MEXICO

in the British Museum

Colin McEwan

Published for the Trustees of the British Museum
by British Museum Press

Acknowledgements

The publication of this guide to the Mexican collections coincides with the opening of the new Mexican Gallery in the British Museum. Our first debt of gratitude must be to our Mexican colleagues who have made this project possible and who are acknowledged in Lord Windlesham's Preface. In addition, we would like to thank Ambassador Jorge Alberto Lozoya, Lic. Rafael Tovar y de Teresa, Lic. Jaime García Amaral (CNCA), Dra. María Teresa Franco and Dr. Felipe Solis Olguín (INAH) who have given us much valued advice. In London successive Ambassadors and their cultural ministers have taken an active interest in the project as it has developed. We especially wish to thank Raul Ortíz y Ortíz, Ramón Brito and Manuel Gameros.

The Gallery itself has been designed by Arquitecto Teodoro González de León whose brief it has been to introduce a distinctly Mexican vision. His flair and high technical standards have ensured a challenging and fruitful collaboration. He has been ably assisted by Miguel Cervantes and by Ernesto Betancourt in developing the plans and the layout. Within the Museum, Christopher Walker, Head of Architectural and Building Services and Margaret Hall, Head of the Design Department have played a major role in implementing the Gallery design. We are also grateful to Design Office staff members Jude Simmons, Gillian Hughes, Teresa Rumble and Denis Calnan for their perseverance and good humour. Conservation Department staff have prepared the objects for display with diligence and enthusiasm. In particular, we would like to acknowledge the work undertaken by Ken Uprichard, Chris Clarke, Karen Birholzer, Karin Hignett, Sandra Smith, Penelope Fisher (stone); Hannah Lane (conservation); Denise Ling, Janet Quinton; Colin Johnson and Man-Yee Liu (organics); and Peter Meehan (metals). Sheridan Bowman and her staff at Scientific Research, notably Andrew Middleton, Mike Cowell and Sylvia Humphrey, have contributed invaluable expertise.

Many scholars and scientists have responded positively to a variety of inquiries on which we have sought their opinion. We are especially grateful to Miguel León-Portilla, Ian Graham, Nikolai Grube, Warwick Bray, Richard Townsend, Richard Diehl, Linda Schele, Gordon Brotherston, Sue Scott, Nick Arnold and Alan Hart.

Within the Ethnography Department Elizabeth Carmichael was closely involved with the early stages of the whole project. The Library staff, in particular, Anne Alexander and Alasdair Reilly, and the conscientious assistance provided by John Osborn, Helen Wolfe, Mike Cobb, Jim Hamill and especially David Noden have all contributed to a successful outcome. Penny Bateman (Education Services) has offered generous support in the realisation of the book and has played a vital role in preparing the programming that will accompany the gallery. We would also like to record our thanks to Norma Rosso who has worked tirelessly as Research Assistant and coordinated many aspects of a complex operation.

The catalogue has benefited greatly from the unstinting efforts of Jane Beamish and Saul Peckham, who took the photographs. We are indebted to Dr Ian Longworth of the Prehistoric and Romano-British Department of the Museum whose talented staff Karen Hughes, Stephen Crummy, Meredydd Moores and Phillip Compton have provided key illustrations. Sue Bird and Hans Rashbrook have contributed additional graphic work of high quality. Finally, we would like to offer sincere thanks to our editor, Carolyn Jones, with whom it has been a particular pleasure to work, especially under the duress of a tight schedule.

© 1994 The Trustees of the British Museum

Published by British Museum Press
A division of British Museum
Publications Ltd
46 Bloomsbury Street,
London WC1B 3QQ

British Library Cataloguing in Publication Data
A catalogue record for this book is available from the British Library

ISBN 0 7141 2516 4

Designed and typeset by John Hawkins Book Design
Printed by BAS

Half title Aztec stone sculpture of the Fire God Xiuhtecuhtli (see p. 70). This youthful central Mexican god of Fire and Time is closely linked to the Fire Serpent Xiuhcoatl (see p. 11). H. 32cm. Ethno. 1849.62-9.8

Frontispiece Maya lintel. A visionary manifestation of an ancestor emerges from the gaping jaws of a serpent poised above Lady Xoc, principal wife of Lord Shield Jaguar, who ruled Yaxchilan from AD 681 to AD 742 (see pp 44–7)

Contents page Classic Veracruz pottery smiling head (see p. 25)

Front cover A stone sculpture representing a Huaxtec female deity (see p. 35)

Back cover Detail of Aztec turquoise mosaic serpent (see p. 80)

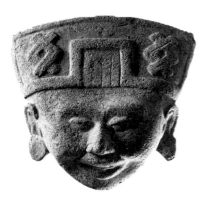

Contents

Preface

by Rafael Tovar y de Teresa
President, Consejo Nacional para la
Cultura y las Artes

The creation of the Mexican Gallery in the British Museum, displaying the collections illustrated in this guide, acknowledges anew the distinguished and singular position that the prehispanic civilisations of Mexico occupy within human culture worldwide.

For long Mexico has been recognised around the world for the unique and priceless legacy left by these civilisations. It is a heritage that is not only of universal significance, but also represents a prized spiritual patrimony, the care of which is of enduring concern to our nation.

Mexicans view with justifiable pride the fact that the British Museum, an institution of international stature, is giving prominent visibility to its collection of Mexican art, enabling it to be seen each year by large numbers of visitors from many countries. In so doing Mexico gains her rightful place among those peoples who stand in the course of history as having fostered great and original cultures.

The significance of this project has awakened the interest of a group within the Mexican business community who have provided the entire financial backing required to ensure its realisation, thereby underlining the important role played by the private sector in supporting cultural projects both within and beyond Mexico's frontiers.

An internationally renowned Mexican architect, Teodoro González de León, has used his vast experience, creativity and knowledge of Mexican cultural traditions to design the gallery. He has achieved a remarkable synthesis of ancient architectural principles and contemporary ideas, harmoniously balancing the space and the objects to do full justice to the range and power of ancient Mexican art.

The Consejo Nacional para la Cultura y las Artes (CNCA), through the Instituto Nacional de Antropología e Historia (INAH) has collaborated with the British Museum in the preparation of the Gallery to offer visitors a concise introduction and new insights into the history of Mexico's ancient cultures. We express our deep gratitude to the Museum staff whose spirit of cooperation and dedicated efforts have assured the successful outcome of the project.

The cultural agreement between the United Kingdom and Mexico which has given birth to the Mexican Gallery will also strengthen fruitful cultural exchange between our two nations. It marks the opening of new possibilities for organising important temporary exhibitions in Mexico drawn from the collections of the British Museum, as well as the reciprocal presentation of Mexican exhibitions in the United Kingdom. We hope that these initiatives will make the very best art and culture available to a much broader public in both countries.

Mexico takes much satisfaction in seeing its cultural presence enhanced in the United Kingdom, above all at the British Museum, where all the great world civilisations meet and where millions of people can admire the extraordinary range and diversity of human culture.

Preface

by The Rt. Hon the Lord Windlesham
Chairman of the Board of Trustees
The British Museum

This introductory catalogue is published to celebrate the creation of a new permanent Mexican Gallery in the British Museum. There has, in fact, been an important Mexican, or more broadly Mesoamerican, presence in the Museum before. For well over 100 years, from the first half of the nineteenth century until the late 1960s, a significant number of the objects illustrated here were part of the exhibits in Bloomsbury. They were also incorporated in displays at their more recent home - the Museum of Mankind - and exhibited on loan elsewhere. It is appropriate that Amerindian cultures should once again find their place in an institution that is renowned for the scope of its collections.

Yet this is correctly described as the 'new' Mexican Gallery. With the consistent support of the Consejo Nacional para la Cultura y las Artes (CNCA) and the Instituto Nacional de Antropología e Historia (INAH), and with funds made available from within the private sector in Mexico, we have sought to forge an exceptional working arrangement for the creation of a new permanent Museum gallery. The Museum's curators, designers and technicians and their Mexican counterparts have worked directly together to enable a vision to emerge which takes account both of Mexican insight and of contemporary scholarship. The gallery has been conceived by Arquitecto Teodoro González de León with assistance from Miguel Cervantes; the INAH has been represented in the British Museum by Dr. Hugo García Valencia. Our own staff have been active and positive partners in deciding on both curatorial and technical issues.

We trust that the Gallery itself, and the publication of this book prepared by Colin McEwan of the Museum's Ethnography Department, amply justify the optimism expressed when I was able to join Lic. Rafael Tovar y de Teresa in Mexico City last year and sign the Agreement which has enabled this innovative cooperation. The presence on that occasion of His Excellency President Carlos Salinas de Gortari, whose personal interest in the Gallery has been an important factor in ensuring its success, and of His Royal Highness The Prince of Wales, underlines the importance we have both attached to this project.

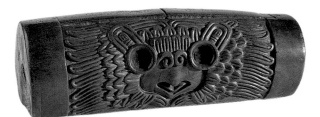

Wooden drum with owl image
Aztec, AD 1300 - 1521
H. 16.5cm x L. 50cm
This horizontal drum (known as *teponaztli* in the Aztec language Nahuatl) is made from a specially chosen wood and embellished with a low relief carving of the head of a horned owl (*tecolotl*). As a creature of the night that nests in hidden recesses, the owl was perceived as an emissary from the underworld.
Ethno. 1949 Am 22.218

Introduction

Mesoamerica stands alongside Mesopotamia, Egypt, India, China and the Andes as a setting for the independent rise of civilisation. Over the course of four millennia, the rich and varied geography of what is now modern Mexico has shaped an extraordinarily diverse array of cultures. The British Museum's collections of Mexican antiquities, which form the basis for this book and for the permanent gallery whose opening it celebrates, themselves have a fascinating history.

In common with the early collections of all major national museums, they are archives of the intellectual and scientific concerns of the period when they were acquired. Those assembled during the eighteenth and nineteenth centuries are essentially a reflection of the eclectic, 'antiquarian' cast of cultural studies at the time. They tend to be diverse in subject and provenance, the result of a somewhat haphazard process of donation rather than any planned, systematic acquisition policy. This is a feature not only of museums in Europe and America, which were the recipients of collections deriving from earlier cultures and distant civilisations, but also of collections preserved in museums in their countries of origin.

The founding of the major museums in Europe gave added impetus to the creation of representative national collections and museums elsewhere. In Latin America in the late nineteenth and early twentieth centuries, the formation of new cultural institutions took place in the context of changing attitudes towards the prehispanic past. The wanton destruction of indigenous culture that was widespread during the early colonial period has gradually been supplanted by concerted efforts to incorporate Amerindian peoples and traditions into emerging national identities. The issues of how, and even whether, this should proceed continue to be the subject of heated debate.

The appropriation of the past to shape a cultural pedigree is not a recent phenomenon. The interests which help mould modern national identities were also present long before the European intrusion into the Americas. The Maya, Toltec and Aztec are only the best-known of many indigenous Amerindian civilisations which bear witness to imperial designs. The process of reassessing and integrating into one's own culture the ideas, objects, and even archaeological sites of previous eras is an ancient practice. Thus, for instance, certain Olmec jades are found preserved and reused as heirlooms in demonstrably Maya contexts (see p. 22). The imposing site of Teotihuacan (see p. 55) with over 100,000 inhabitants at its peak around AD 600, though virtually deserted by Aztec times, was still revered as the 'City of the Gods'. Furthermore, the frontiers of successive Mesoamerican civilisations were always fluid and permeable, and do not correspond to any modern national or provincial boundary. At its apogee Maya culture embraced an area covering much of what is now Guatemala, Belize and Honduras as well as Mexico. The complex histories underlying cultures and the artefacts

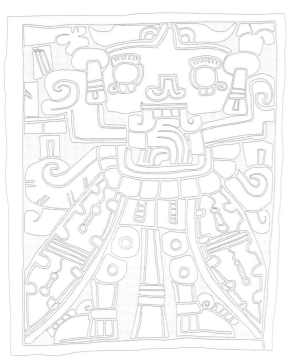

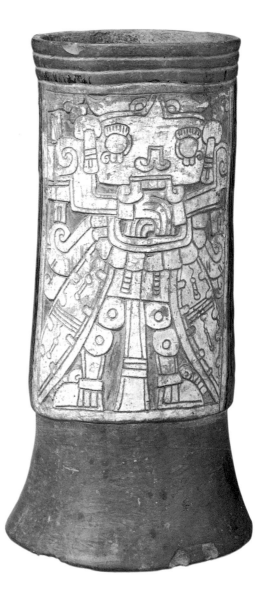

Pottery vessel with ritual impersonator
Postclassic Veracruz, AD 900 - 1200
H. 21. 5cm x DIAM. 11.5cm

The individual depicted on this vessel wears a bee costume. Ritual attire was used in seasonal festivals to impersonate nature deities and portray the figures that peopled Mesoamerican mythologies. The Fine Orange Ware from which the vessel is made was manufactured on the Gulf Coast and traded widely during the Postclassic. Later imitations of the cylindrical form have been found interred at the Templo Mayor, the principal temple of the Aztec capital, Tenochtitlan.

Given by A.W. Franks
Ethno. 8412

they produce will always be the source of lively scholarly and public debate - not least the contested questions of origins and ownership.

Most of the British Museum's prehispanic collections from Mexico came into the Museum during the last century. Some of the earliest pieces were first exhibited by the antiquarian

William Bullock in an 'Egyptian Hall' in London's Piccadilly. Bullock had travelled and collected in Mexico towards the end of 1822, within a year of Mexican Independence. A succession of travellers, diplomats and scholars (Alfred Maudslay outstanding among these) added to the collections over the years.

Most objects are of stone or pottery but some organic materials survive, notably beautifully carved Aztec-Mixtec wood drums (see illustration p. 7), and stunning turquoise mosaics (see pp 71-80). Fragile prehispanic and early colonial codices (painted books, see pp 62–3) have proved invaluable in decoding diverse literary traditions and in gaining insights into Mesoamerican calendrical systems and social structure. Textiles, unfortunately, are seldom preserved in most archaeological contexts despite being a major item of trade and tribute.

The collecting biases of earlier generations have resulted in an extraordinary range of images depicting the human form. The view presented here of Mexican antiquity is, therefore, a thoroughly 'peopled' one. Modern ethnographic and archaeological scholarship has brought significant new insights to our understanding of many objects and their place in the ritual events and cycles that underpinned Mesoamerican culture. The key actors in certain dynastic histories can now be identified thanks to the recent remarkable advances in interpreting Maya glyphs. The suite of Maya lintels from Yaxchilan (see Frontispiece and pp 44–7) have provided vital clues in this breakthrough.

We understand as never before that the interplay between the human world and the natural forces which shape its affairs was of paramount concern to Mesoamerican peoples. The themes of creation, death and rebirth permeate all of Mesoamerican mythology and belief and the art to which it gives rise. Transitions and metamorphoses are marked in both time and space, and expressed in masks and ritual attire (see Veracruz vessel, p. 9). Within the human life cycle rites of passage are a common occasion for much artistic endeavour - objects and costumes associated with ceremonies of birth, naming, initiation, accession and death. Each event was used to remind the participants of the presence of ancestral, spiritual sources of regeneration and life, recourse to which was a human obligation. Seasonal cycles were likewise the occasion for festive celebration and mountain-top pilgrimages.

Political rivalries were contested in the ball game, an integral element of Mesoamerican culture. The paraphernalia worn by the players is richly iconic, whilst the ball-court itself is bounded by motifs that signal its significance as a threshold with cosmic overtones, for the losers were liable to be offered as propitiatory sacrificial victims (see pp 28-9).

Many ritual objects embody powerful nature deities and spirits whose attributes are described in myth. Their distinctive signifying icons and symbols are rendered sculpturally in durable materials such as stone, thereby validating mythical accounts of creation and reinforcing and legitimising claims to rulership (see Xiuhcoatl, 'Fire Serpent', p. 11). Among the best known figures are Tlaloc, the Rain God, (see p. 55) and Quetzalcoatl, the Feathered Serpent (see pp 68-9). Images of these and other deities in the Mesoamerican pantheon appear at Teotihuacan and persist across much of Mesoamerica for another 1500 years. As cult objects they became focii of supernatural power and their incorporation into the iconography and architecture of all major ceremonial centres marks the threshold dividing sacred space from the everyday human world.

The pyramids, temples and monumental sculpture of Mesoamerica bear comparison with the imposing man-made ziggurats of Mesopotamia, the pyramids of Egypt and the palaces and tombs of Assyria. Similarly the

cosmography governing the layout of Mesoamerican cities can be compared to the geomancy used in planning early Chinese urban centres. The understanding we now have of New World astronomical, calendrical and writing systems offers new insights into cross-cultural studies of social evolution. From the vantage point of the twentieth century, and with the benefit of the hindsight which museum collections permit, we can survey the rise and fall of Mesoamerican civilisation and set it in context beside the other great epochs of human culture.

This encounter intimates other ways of seeing the world and challenges our faculties of perception and imagination. We do more than merely confront each new object and image passively. We bring our own participation to bear in the act of cognition and learn not only of other times and places but also, perhaps, something more of ourselves.

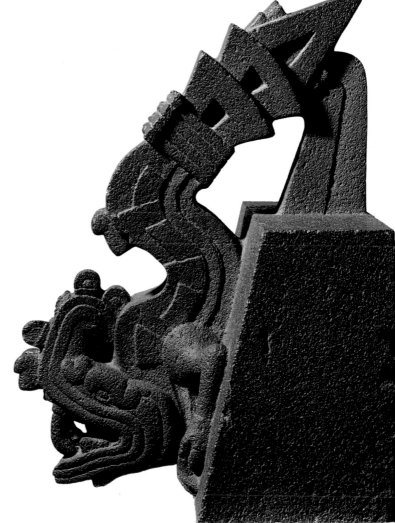

Stone Fire Serpent, Xiuhcoatl
Aztec, AD 1300 - 1521
H. 77cm x W. 60cm
The Aztecs conceived of heat and fire in many guises. The Old Fire God in the bowels of the earth, Xiuhtecuhtli, could provoke outpourings of molten lava from volcanic eruptions. The destructive consequences of solar fire could upset the balance of nature by causing drought and famine. Here a fire serpent, Xiuhcoatl, is sculpted as a jagged, serpentine bolt of lightning striking earthwards from the sky.
Ethno. 1825.12-10.1

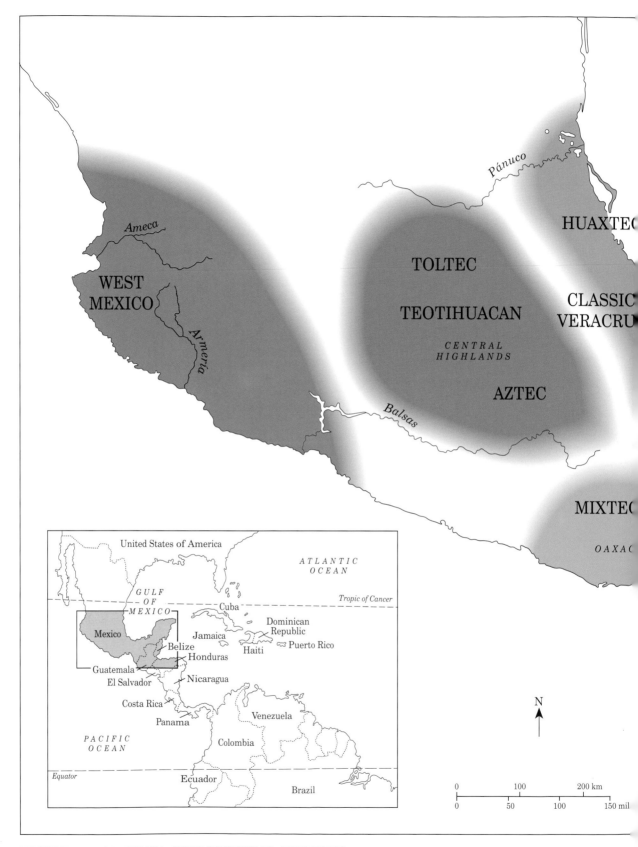

Ameca

HUAXTEC

WEST
MEXICO

TOLTEC

TEOTIHUACAN

Armería

CENTRAL
HIGHLANDS

CLASSIC
VERACRU

AZTEC

Balsas

MIXTEC

OAXAC

United States of America

*ATLANTIC
OCEAN*

*GULF
OF
MEXICO*

Tropic of Cancer

Cuba

Mexico

Jamaica

Dominican
Republic

Puerto Rico

Belize

Haiti

Guatemala

Honduras

El Salvador

Nicaragua

Costa Rica

N

Panama

Venezuela

*PACIFIC
OCEAN*

Colombia

Equator

Ecuador

Brazil

0		100		200 km
0	50	100		150 mil

ANCIENT MESOAMERICA: THE PRINCIPAL CULTURES

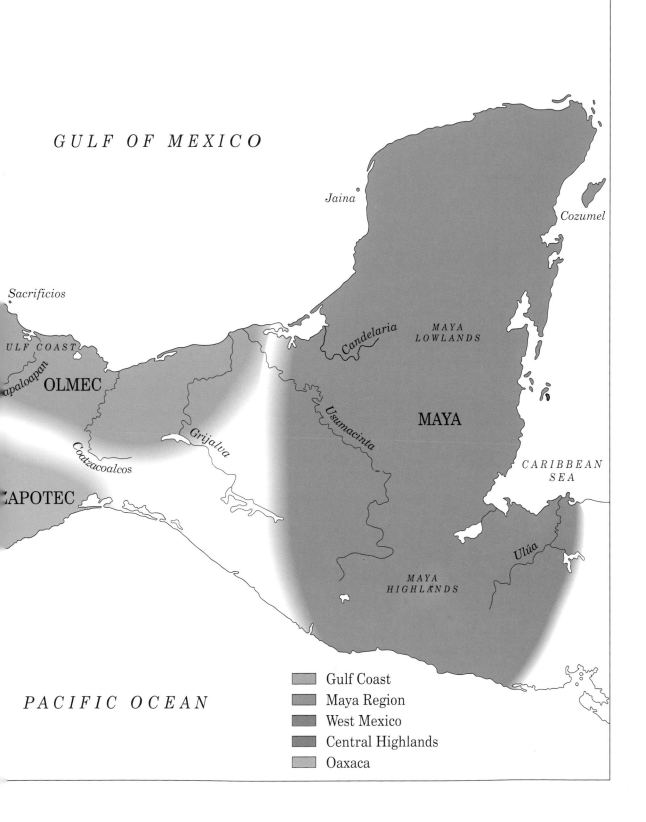

GULF OF MEXICO

Jaina

Cozumel

Sacrificios

GULF COAST

apaloapan

OLMEC

Candelaria

MAYA
LOWLANDS

Usumacinta

MAYA

Grijalva

Coatzacoalcos

CARIBBEAN
SEA

ZAPOTEC

Ulúa

MAYA
HIGHLANDS

PACIFIC OCEAN

	Gulf Coast
	Maya Region
	West Mexico
	Central Highlands
	Oaxaca

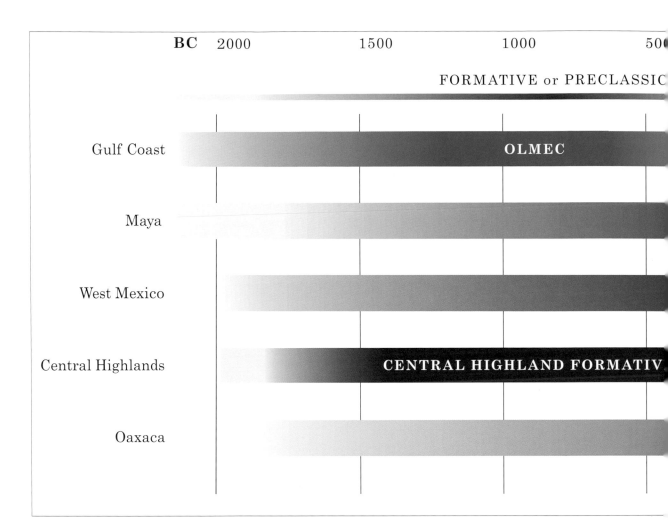

This chronological chart emphasises the period of maximum achievement and influence of each culture, traditionally referred to by archaeologists as a 'Classic' period. Nevertheless, the 'Classic' in every region is invariably preceded by a long history of Formative or 'Preclassic' cultural development. Likewise, there is considerable cultural continuity on into the 'Postclassic' and beyond the fall of the Aztec capital, Tenochtitlan, in 1521 AD. Despite the destruction and dislocation of centuries of European colonisation, indigenous Amerindian culture flourishes in many parts of Mexico to this day.

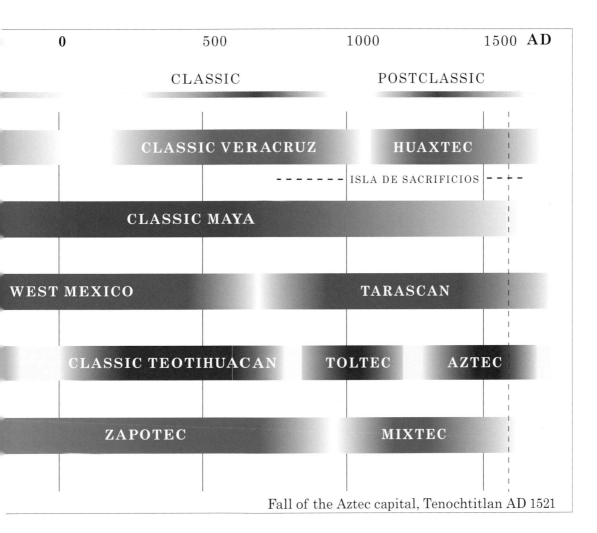

0	500	1000	1500 **AD**

CLASSIC POSTCLASSIC

CLASSIC VERACRUZ HUAXTEC

ISLA DE SACRIFICIOS

CLASSIC MAYA

WEST MEXICO TARASCAN

CLASSIC TEOTIHUACAN TOLTEC AZTEC

ZAPOTEC MIXTEC

Fall of the Aztec capital, Tenochtitlan AD 1521

Stone head of Tlaloc *(See pp 55, 74)*
Aztec, AD 1300 - 1521
H. 23cm x W. 22cm

Given by the Wellcome Historical Museum
Ethno. 1954.Am 5.1473

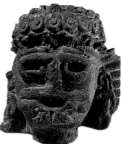

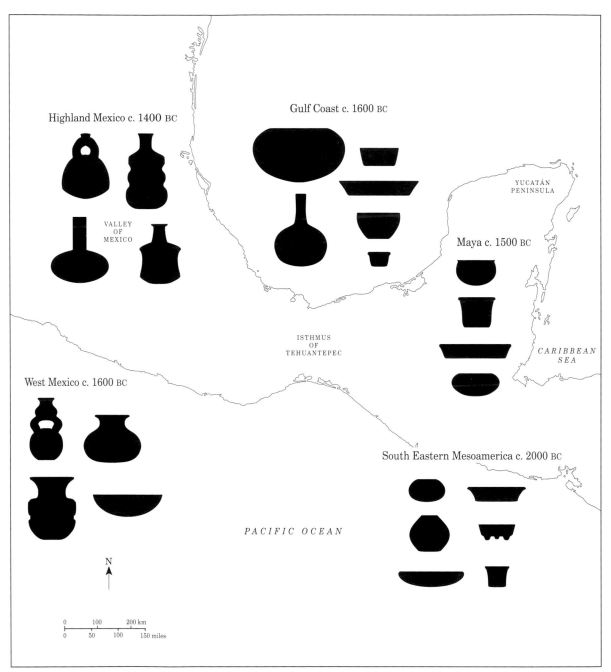

MESOAMERICA: EARLY FORMATIVE POTTERY COMPLEXES

Pottery first begins to appear in Mesoamerica around 2000 BC. The earliest pottery complexes usually consist of cooking and serving vessels: pots, jars, plates and bowls. Some examples are shown above. There are important differences in vessel forms between the various complexes, although the sources of all these have not yet been securely identified. Much earlier pottery in the lowlands of northwestern South America dates back to at least 4000 BC and some Mesoamerican vessel forms, especially in West Mexico, clearly owe their inspiration to antecedent South American forms. The spread of domesticated plants, pottery and metallurgy points to a complex history of diffusion, trade and exchange between the South American continent and Mesoamerica that goes back for many thousands of years.

Formative

(2500 – 400 BC)

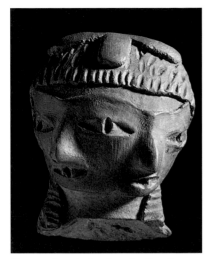

Pottery head of a female figurine
Tlatilco, 1500 - 900 BC
H. 3.5cm
Figurines with three faces and others with different anatomical anomalies were created by early Formative artists.
Given by I. Bullock
Ethno. 1949 Am 13.17

The transition from hunting and gathering subsistence economies to settled village life is known to archaeologists as the Formative or, more traditionally, the Preclassic. In Mexico this process gathered momentum during the late third and early second millennia BC and is marked by the appearance of the first pottery and well-developed agriculture based on the domesticated staple plants: corn, beans and squash. By 2000 BC, archaeological evidence for settlements and pottery is found on the Pacific coast of southern Mexico and Guatemala, spreading from there to the Gulf Coast and to the Maya highlands. In West Mexico a distinctive range of vessel forms appears by 1600 BC, followed by shaft and chamber tombs (see pp 49-50). To varying degrees the lowland coastal traditions influenced the first pottery vessels and figurines found a little later in the Mexican highlands (see p. 53). Sustained population growth and an increasing mastery of natural resources laid the foundations for flourishing regional cultures. A veritable mosaic of different languages, dialects and contrasting art styles evolved, yet all Mesoamerican civilisations share an underlying set of cosmological beliefs and calendrical practices.

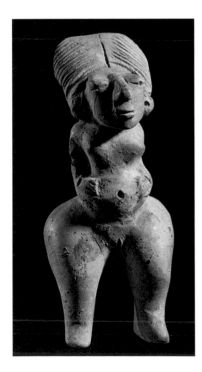

Pottery female figurine
Upper Panuco Valley, 1500 - 900 BC
H. 8.4cm
Groups of miniature female figurines which have been found in Formative burials may have been used in household shrines and fertility rituals as well as being companions for the dead.
Ethno. 1936 RWB 15

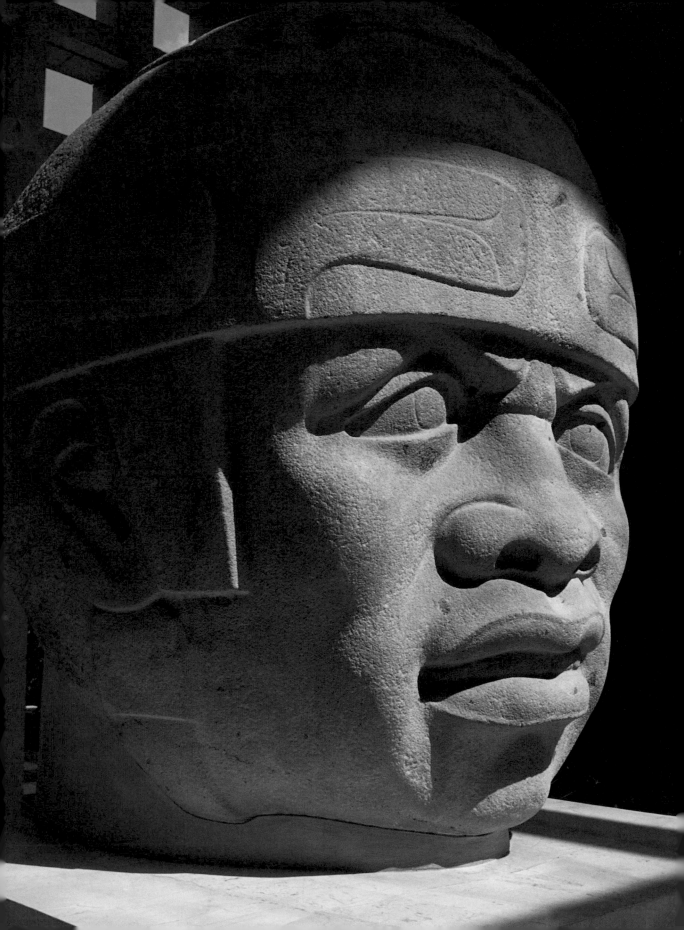

Votive jade axe
(detail - see pp 20 -21)
The 'flame-eyebrow' motif is
derived from the brow ridge
of the caiman, a crocodilian
with fearsome jaws.

Olmec

(1200 – 400 BC)

Olmec culture finds its highest expression in what is known as the Olmec heartland on the Gulf Coast of Mexico. In this lowland, riverine setting well-planned political-ceremonial centres such as San Lorenzo, Tres Zapotes, Laguna de los Cerros and La Venta emerged in the late second millennium BC. Notable features of these centres are public plazas, impressive earthen platform mound architecture and monumental portrait heads of Olmec rulers sculpted in stone. In recent excavations Mexican archaeologists have uncovered portions of satellite residential communities. Ceramic and lapidary arts flourished as jade and other sought-after exotic materials flowed into the region through long distance exchange networks. The Olmec art style is found on objects as far afield as the Valley of Mexico to the north and the Pacific coast of Chiapas to the south, pointing to a widely shared set of beliefs that was to have a profound influence on many later Mesoamerican stylistic traditions.

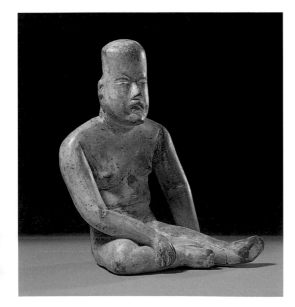

Seated pottery figure
Olmec, 1200 - 400 BC
H. 15.5cm x w.11.5cm
The use of fine white kaolin clays imbues this 'baby' pottery figure with a plastic, life-like quality. Traces of a vivid red pigment that was applied on top of the white slip are still visible.
Given by the Trustees of the Wellcome Historical Medical Museum
Ethno. 1981. Am 27.1

Facing page **Colossal head, no. 8**
Olmec, San Lorenzo, 1200 - 400 BC
Museo Arqueológico de Xalapa, Veracruz, Mexico
This monumental head, standing over two metres tall and weighing many tons, is a portrait of an Olmec ruler. It is sculpted in basalt, obtained from the Tuxtla Mountains and transported overland and by raft to San Lorenzo.

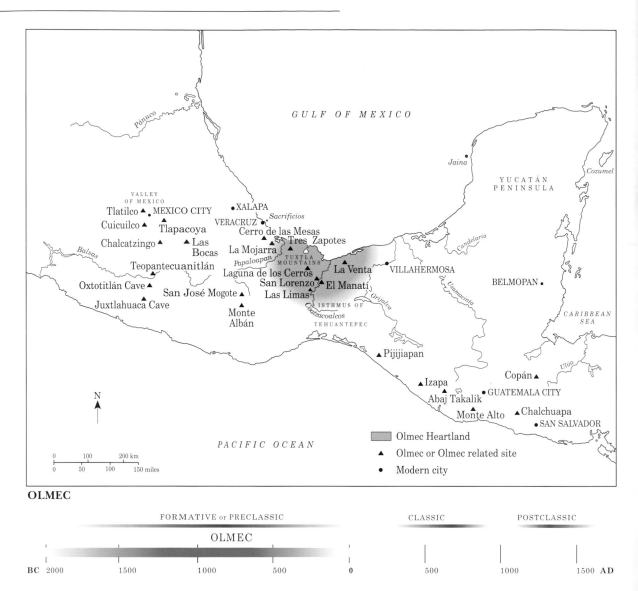

OLMEC

FORMATIVE or PRECLASSIC			CLASSIC	POSTCLASSIC
OLMEC				
BC 2000 1500 1000 500	0	500	1000	1500 AD

Facing page **Votive jade axe** *(See note below)*

Olmec, 1200 - 400 BC
H. 29cm x W. 13.5cm

This massive ceremonial axe combines characteristics of the caiman and the jaguar, the most powerful predators inhabiting the rivers and forests of the tropical lowlands. The pronounced cleft in the head mimics the indentation found on the skulls of jaguars and has also been compared to the human fontanelle. Elsewhere in Olmec iconography vegetal motifs spring from similar clefts and orifices, alluding to the cthonic (underground) sources of fertility and life. The crossed bands glyph incised on the front of the breech cloth represents an entrance or opening and is repeated on the jade perforator (see p. 23). The combination of symbols on the axe proclaims its magical power to cleave open the portals into the spiritual world. Utilitarian objects were often personified in this way to represent the qualities and attributes of supernatural deities. Imbued with accumulated inner soul-force, they became potent objects handed down from one generation to the next.

Ethno. St. 536

Jade: Pending mineralogical analyses, the term 'jade' is used here to include both the two principal jade minerals, nephrite and jadeite, as well as possible jade simulants such as amazonite and serpentine.

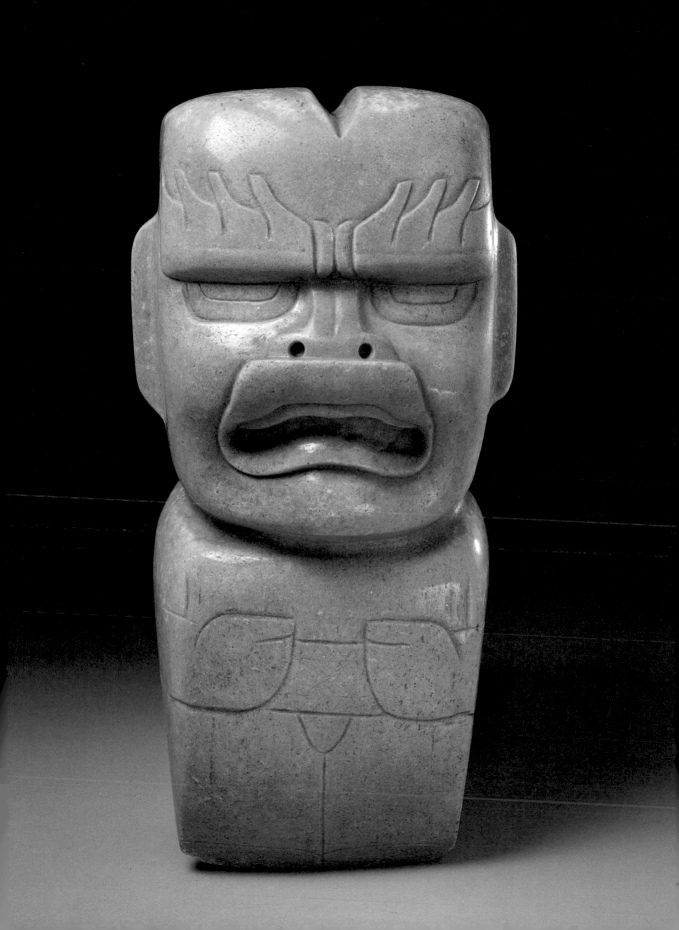

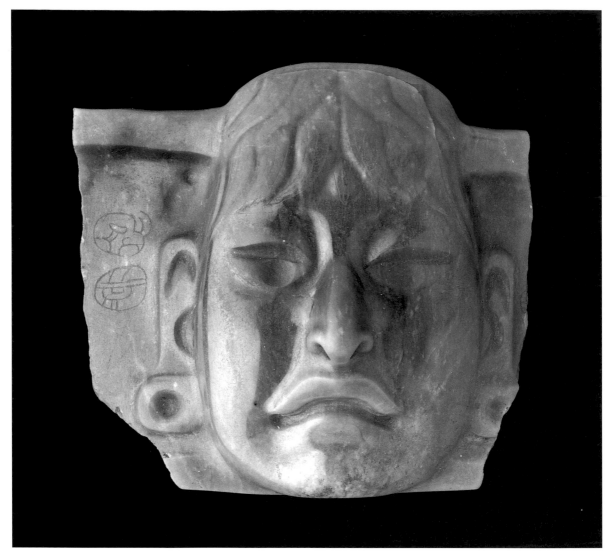

Jade pectoral

Olmec, 1200 - 400 BC
re-used by Maya AD 100 - 900
H. 10. 3cm x w. 11.3cm

This portrait is a remarkable example of the finest Olmec lapidary art. It
was designed to be worn as a pectoral and the pair of Maya name glyphs
inscribed on one flange indicate that it was later reused by a Maya lord as
a treasured heirloom. Unusually the glyphs are drawn backward so that
they face the Olmec portrait, hinting at the power of the object as a
symbol of ancestral, dynastic authority. The depressed iris of the eyes
and the pierced nose probably bore additional shell work and ornament.

Given by Mrs Yates Thompson
Ethno. 1929. 7-12.1

Jade perforator

Olmec, 1200 - 400 BC
H. 38cm x W. 3cm

Perforators may have been used as early as Olmec times in bloodletting rites associated with royal accession. Although no direct representation of these rites is found in Olmec art, bloodletting forms a central theme in the scenes depicting Maya accession rituals (see Yaxchilan lintels pp 44-7). The pair of motifs on the head of this instrument are linked to a supernatural fish being, pointing to the marine source of other widely-used perforators such as sting-ray spines and sharks' teeth. The size of this object and the material in which it is fashioned suggest that, like the votive axe, it served a largely symbolic function, forming part of the ritual regalia and visual vocabulary of motifs which were the prerogative of Olmec rulers. See, however, Maya lintel 17 (p. 47) on which a perforator of comparable size is clearly intended to be used.

Given by the Misses Thornton
Ethno. 1907. 6-8.3

Stone mask with cleft-like facial markings

Olmec, 1200 - 400 BC
re-used by Maya AD 100 - 900
H. 12. 5cm x W. 11.2cm

This mask in serpentinite stone was found in the Maya lowlands but appears to be Olmec in origin. The pair of fine-line incised motifs on each cheek echo the cleft element found on the large votive axe (see pp 20-21), and on the perforator glyph above (see also pp 55, 57). The four motifs symbolically define the four quarters of the human world with the king as ruler at the centre (see pp 76-7).

Bequeathed by Thomas Gann
Ethno. 1938. 10-21.14

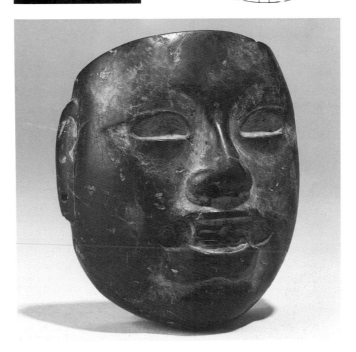

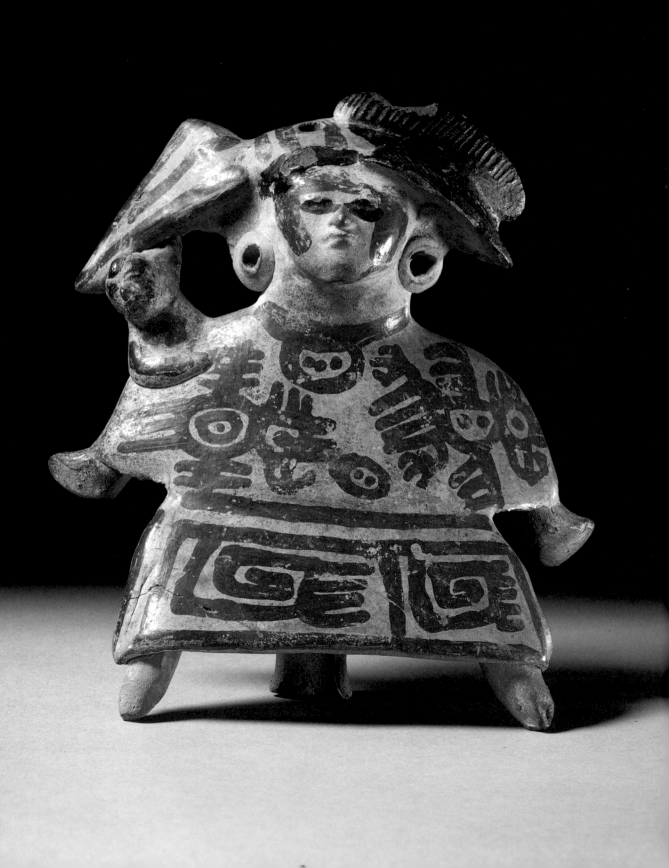

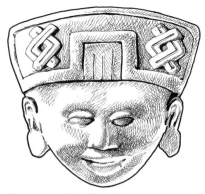

Pottery smiling head
(see photograph p. 5)
Classic Veracruz, AD 300 - 1200
H. 14cm x W. 13.5cm
Smiling and laughing ceramic
figurines with outstretched arms
have been found in groups
surrounding high-status burials in
southern Veracruz.
Ethno. 1950 Am 20.21

Pottery smiling head
Classic Veracruz, AD 300 - 1200
H. 14cm x W. 18cm
Like the one above, this smiling
head originally formed part of a
whole figurine. These may
represent individuals who were
given an inebriating potion before
being sacrificed to accompany the
deceased.
Ethno. 1975 Am 8.3

Classic Veracruz

(AD 300 – 1200)

After the initial Olmec florescence, the focus of Gulf coast
civilisation shifted northward to regional political and
ceremonial centres such as El Tajín. A vigorous and
distinctive art style spread from southern Veracruz,
eventually to exert an influence as far afield as Teotihuacan
and the Toltec capital of Tula. A constant flux of ideas and
trade strengthened the links between the Gulf coast lowlands
and the highlands. One expression of this is the
development of a formal ball game with well-defined playing
courts and elaborate rituals, variants of which were widely
adopted throughout Mesoamerica. Sanctuaries and shrines
which were originally the focus of local cults became part of
a more extensive 'sacred geography' that embraced
mountains, lakes and islands and other significant features in
the natural landscape (e.g. Isla de Sacrificios, see pp 30-33).
Seasonal rites and ceremonies were gradually incorporated
into a formal calendar which revolved around the
agricultural cycle.

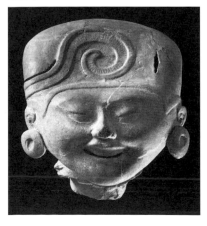

Facing page **Pottery figurine of a woman bearing a child**
Classic Veracruz, AD 300 - 1200
H. 15.7cm x W. 14cm
A pair of birds adorn the *quechquemitl* (mantle) worn by this woman.
Her elaborate attire and flamboyant headdress, like those on similar
figures from the Remojadas and El Faisán areas of southern Veracruz,
suggest that she may be a participant in festivities celebrating the
seasonal movement of birds and animals marking the onset and
cessation of the rains. The object's function as a whistle lends support
to this idea. Black *chapopote*, a blend of tar and rubber, has been
daubed on the figure. This is often applied to figurines dedicated to
the earth deity.
Given by Richard Woolett
Ethno. 1977 Am 38.1

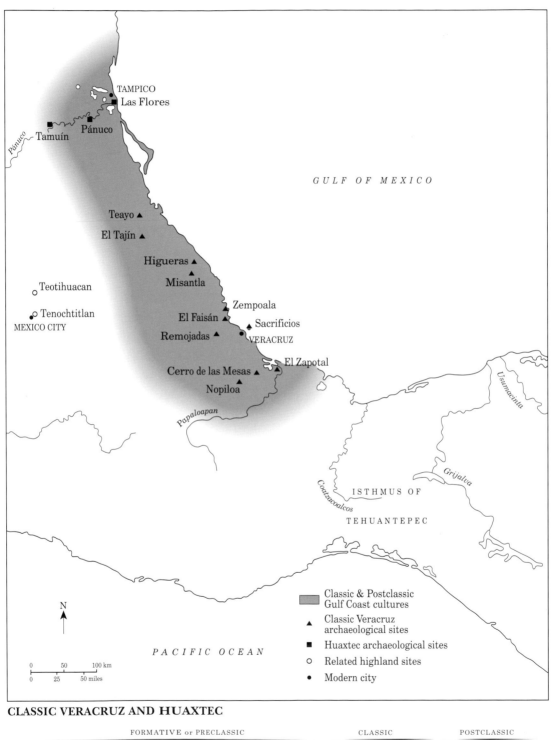

CLASSIC VERACRUZ AND HUAXTEC

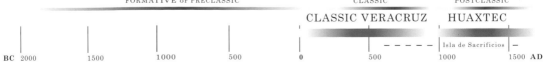

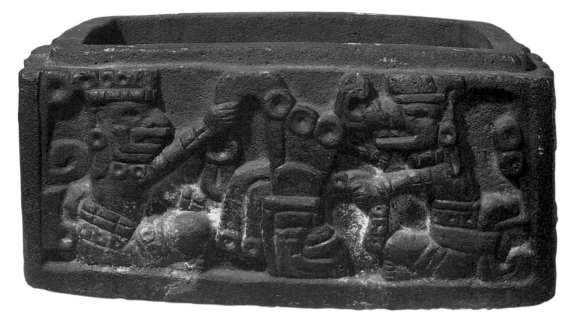

Stone vessel *(side B below)*
Classic Veracruz, AD 300 - 1200
H. 36cm x D. 115cm

The scenes carved on the four sides of this vessel depict two protagonists engaged in a formal contest over a severed trophy head with a tasselled plume of long hair. The left-hand figure always wears a distinctive nose ornament that extends across his cheek, while the fanged jaws of his opponent emphasise his supernatural powers. Their confrontation is played out in a sequence of arm gestures which are the mirror image of each other, and change in synchronised fashion from scene to scene. Subtle variations in the costume and headdress of each figure reveal a series of complementary oppositions that echo and elaborate upon the visual language of the arm gestures. A linear reading of the scenes from A to D, following the direction in which the trophy head is facing, culminates in a gesture of mutual recognition and presentation. On the other hand pairs of panels can be opposed in differing combinations. It seems likely that the vessel held a liquid, perhaps *pulque*, the fermented beverage made from the juice of the *maguey* plant (see p. 35, Huaxtec), which was consumed in large quantities at festivals. It probably served as a ritual object employed in the course of a round of related ceremonies, among them the ball game, celebrated at designated times of the year (see p. 29, stone altar relief).

Ethno. Q 89 Am 4

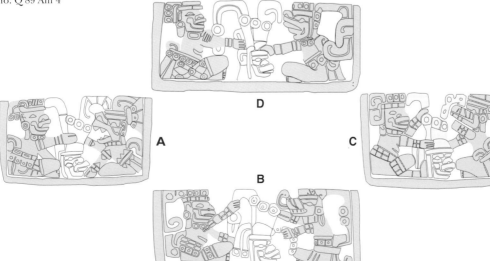

D

A

C

B

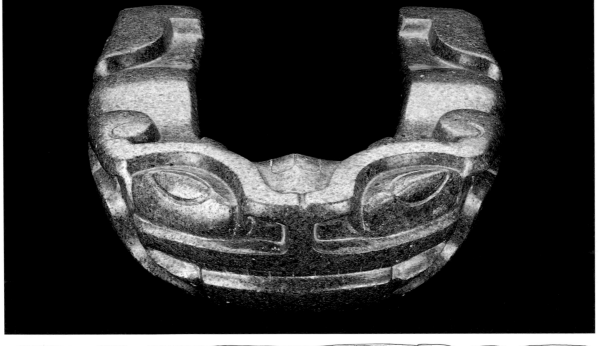

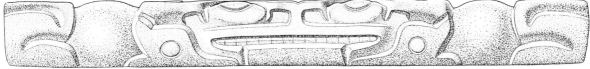

Stone mould
(for making ball game belt)
Classic Veracruz, AD 300 - 1200
H. 12cm x W. 39.5cm

Although commonly referred to as 'yokes', these magnificently-sculpted objects were used as moulds for shaping the protective leather waist belts worn by ball game players. The dense, non-porous, highly-polished dioritoid stone provided an ideal base upon which to fashion wet leather. When dry, the belt was stuffed with soft padding (perhaps cotton, or kapok from the ceiba tree) and then secured around the waist to cushion the impact of the heavy rubber ball. Beyond this practical function the belt was charged with special symbolic significance. The creature depicted is a toad - a zoomorphic representation of the earth. With the belt at mid-body, the player stood in the navel of the toad at the threshold to the underworld. The ball-court itself was a carefully circumscribed sacred space and a symbolic entrance to the spiritual world, hence the outcome of certain ball game contests which ended in sacrifice by decapitation (see Mixtec, p. 62, for a picture of a ball-court from the Codex Zouche-Nuttall.)

Ethno. St. 398

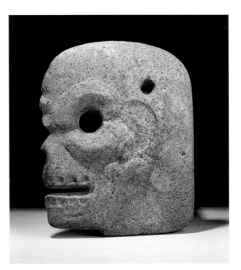

Skeletal stone head
Classic Veracruz, AD 300 - 1200
H. 26.3cm x W. 2cm

The hard rubber ball used in the ball game was likened to a human head and indeed trophy heads and skulls are frequently depicted on portable stone ball-court sculpture. This particular form is often misleadingly referred to as an *hacha* (Spanish for axe). It probably served as a mould, like that illustrated above, to make a leather object which was then attached to a ball player's waist belt. It may also have projected from a ball-court wall as a marker (see p. 29).

Ethno. 1891.11-19.1

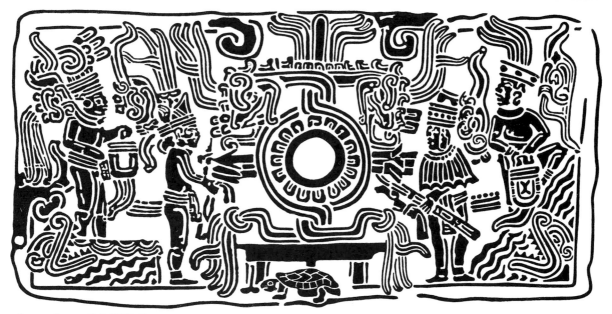

Stone altar relief, El Tajín
Classic Veracruz, AD 300 - 1200

A large vat, similar to the stone vessel illustrated on p. 27, appears in the left foreground of a ritual scene depicting rites of accession or rulership (see also Maya, pp 38-47) on an altar relief from Building 4, El Tajín. The central axis of the composition is marked by two entwined serpents which encircle an orifice cut through the slab and can be compared with a *tlaxmalacatl*, or ball-court marker (see below). This is located above a low throne under which stands a turtle as symbol of the earth (see Huaxtec p. 36). The ascendant lord is thus legitimising his claim to the throne from which he will rule the known world.

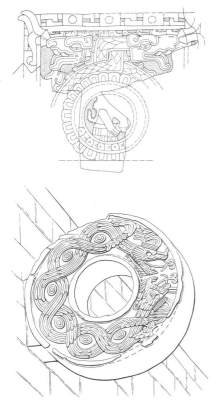

Stone panel no. 8 from the Pyramid of the Niches, El Tajín
Classic Veracruz, AD 300 - 1200
H. 96cm x W. 106cm

On this panel a pair of feathered serpents wind round a plumed circle containing the arm and costume of a human figure. The image parallels the form of the ball-court marker found several centuries later at the distant site of Chich'en Itza (see below).

Stone ball-court marker, Chich'en Itza
Maya, AD 1000 - 1200
DIAM. approx. 100cm

A pair of entwined feathered serpents encircle the ball-court marker (*tlaxmalacatl*) through which the ball had to pass to win or lose the game. Placed high on the wall of the great ball-court at Chich'en Itza in the Yucatan Peninsula, the marker with its serpent motif signals the fact that the court stands at the boundary between the human domain and the spiritual world.

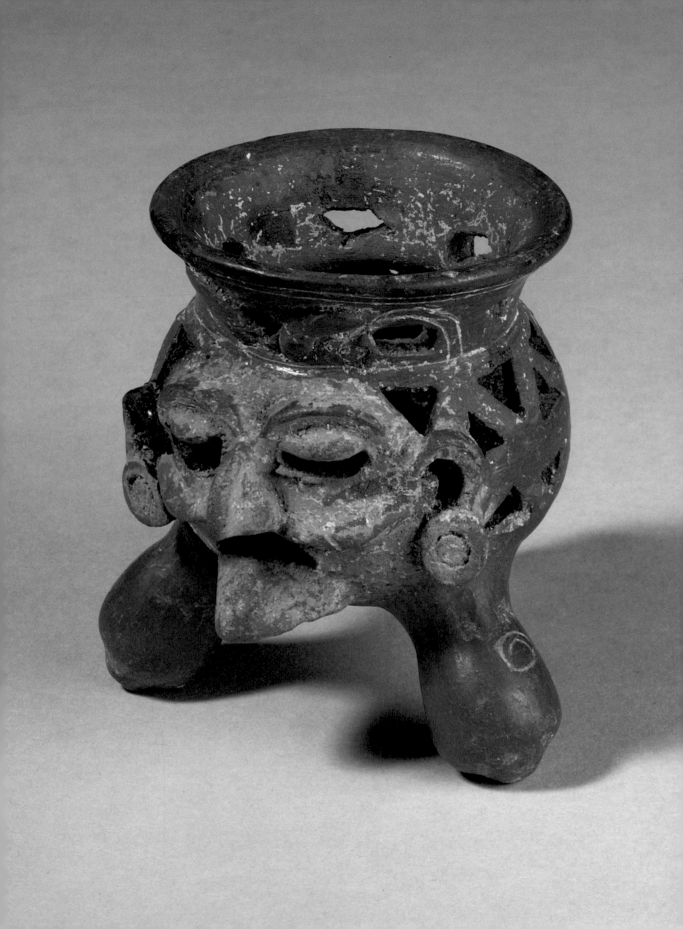

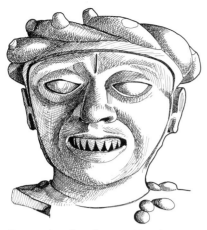

Pottery head and torso *(detail)*
Isla de Sacrificios, AD 900 - 1521
H. 26cm x W. 22cm
Large, almost life-size, pottery figurines may have been placed as attendants or guardians in close proximity to cult images in the temples on Isla de Sacrificios.
Ethno. 1844.7-20.849

Pottery bowl
Isla de Sacrificios, AD 900 - 1521
H. 10.5cm x W. 15.5cm
The bold black-on-white abstract design on this bowl is typical of the Panuco Valley on the northern Gulf Coast from where it must have been brought or traded.
Ethno. 1844.7-20.1105

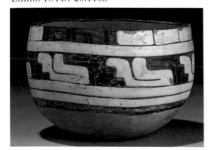

Isla de Sacrificios

(AD 900 – 1521)

The Spanish navigator Grijalva first set foot on this low, sandy coral island a few miles southeast of the port of Veracruz in the spring of 1518. He reported impressive architectural features including massive platforms, an imposing arch and a circular tower, at the foot of which lay recent human sacrifices. Over the years a succession of travellers, looters and archaeologists have unearthed a wealth of extraordinary burials on the island, including many objects brought from the central highlands and even further afield. The vestiges of polychrome murals depicting Quetzalcoatl on one of the surviving temple façades suggest that the principal shrine on the island was dedicated to this and perhaps other deities. From local beginnings in the first millennium BC the sanctuary steadily grew in importance, so that by the early Postclassic it was attracting offerings of objects that were being widely traded by Toltec merchants. In Aztec times the strong mythical connection between the figure of Quetzalcoatl and the direction East may have been reinforced by pilgrimages from the Aztec capital, Tenochtitlan, to the coast, intended to ensure the onset of the seasonal rains.

Facing page **Pottery tripod incense burner**
Isla de Sacrificios, AD 900 - 1521
H. 9cm x W. 9.5cm
Small 'openwork' incense burners were used to hold offerings of smouldering, aromatic resins such as *copal*. The sunken facial features of the Old Fire God, later known to the Aztecs as Huehueteotl, are modelled on the front. The blue pigment alludes to Tlaloc, the Rain God. In Aztec thought the conflation of these polarities was used metaphorically to refer to war. Similar censers were popular among the Toltecs, and this object is likely to have been carried from the highlands to the coast to fulfil a ritual obligation.
Ethno. 1844.7-20.931

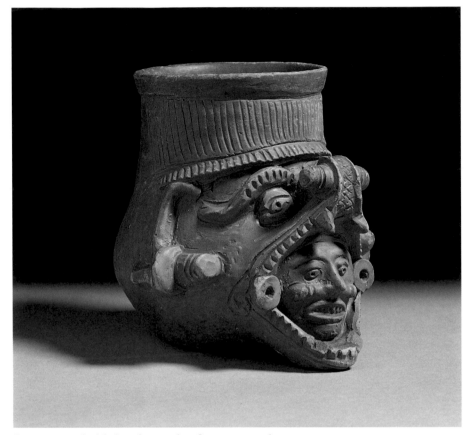

Pottery vessel with head emerging from serpent jaws
Isla de Sacrificios, AD 900 - 1521
H. 12.7cm x W. 12cm
A human emerging from the jaws of a serpentine dragon is a recurring image in
Mesoamerican art. Among their many other connotations, snakes were seen as a
metaphor for the umbilical cord connecting new life on the earthly plane with the
hidden, spiritual sources of creation. Such images, therefore, evoke ancestral
connections and call attention to the threshold dividing the human domain from
the invisible but ever-present ancestral spirits (see pp 45-6 and 77).
Ethno. 1844.7-20.971

Facing page **Calcite onyx vessel showing a seated figure wearing a feline mask**
Isla de Sacrificios, AD 900 - 1521
H. 21cm x W. 11cm
Translucent white stone *(tecalli)* was reserved for special ritual objects. It was quarried
in the Mexican highlands, so this vessel may have been fashioned by Mixtec
craftsmen. The seated figure is a warrior wearing a feline cloak and mask. His formal
seated posture suggests that he is undergoing a rite, possibly induction into a
military order (see also Aztec eagle warrior, p. 74).
Ethno. 1851.8-9.2

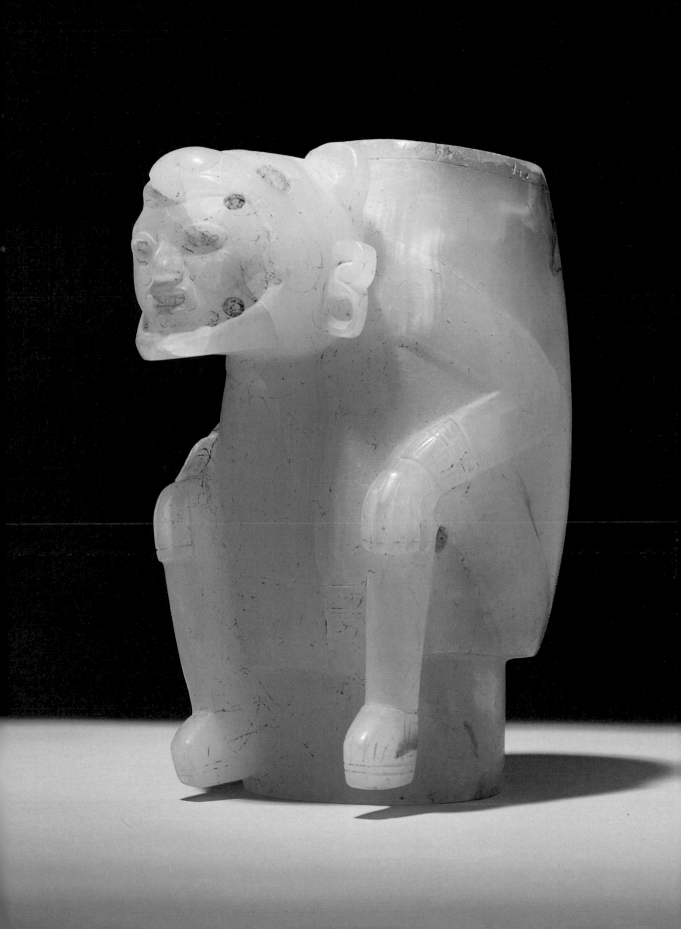

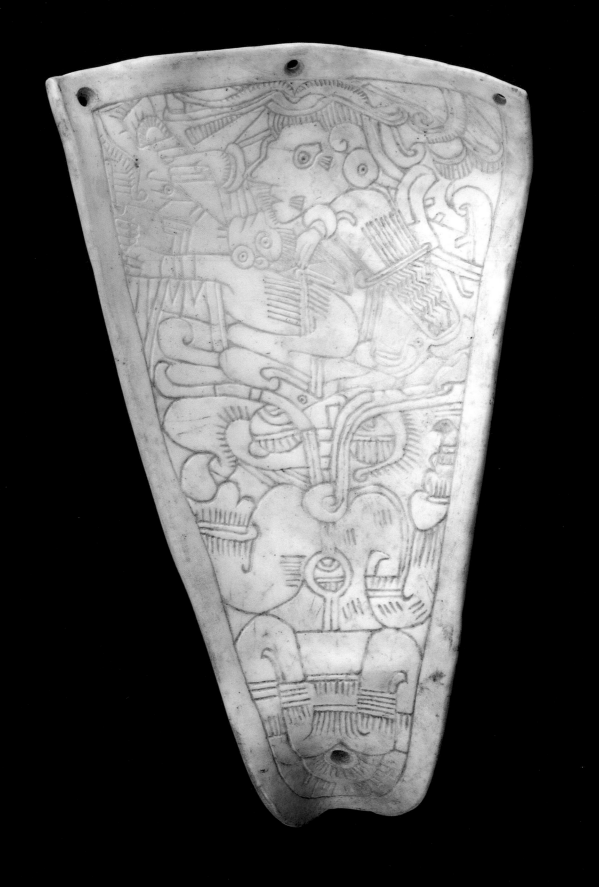

Huaxtec

(AD 900 – 1450)

Stone sculpture of female deity
(See cover)
Huaxtec, AD 900 - 1450
H. 150cm x W. 57cm
Sculptures of Huaxtec feminine
deities once stood in shrines and
temples as the object of seasonal
fertility rituals. Offerings of food
and drink were made to these cult
images at planting and harvest
times, symbolising the need to both
feed the earth and thank it.

Ethno. Q 89 Am 3

As Classic Veracruz civilisation waned, northern Gulf Coast
Huaxtec peoples continued to thrive. Huaxtec languages are
related to those of the Maya, from whom they had diverged
by about 1500 BC. By the Postclassic they were at the hub of a
trading network that extended across the Gulf of Mexico to
the southeast United States and up into the central Mexican
highlands. In the mid-fifteenth century they were conquered
by the Aztecs. Among the surviving Huaxtec monuments is
an outstanding corpus of sculpture in stone, and Gulf Coast
influences can be detected in Aztec sculptural styles (see p.
75). Much remains to be discovered concerning the
archaeology of this zone, but a rich body of contemporary
folklore and colourful festivals preserve prehispanic
elements which provide intriguing insights into the
significance of many objects.

The deity Tlazolteotl with *maguey* plant
In this image (inverted) from the highland *Codex Borgia* Tlazolteotl
bears a *maguey* plant (*Agave sp.*), recognisable by its long pointed leaves.
The fermented sap of this plant was used to make the frothing,
intoxicating beverage called *pulque* which was likened to mother's milk.
The deity wears a triangular shell pendant suspended from her neck,
like the one illustrated on the facing page.

Facing page **Shell pendant**
Huaxtec, AD 900 - 1450
H. 16cm x W. 9.5cm
The scene inscribed into the surface of this pendant depicts an
individual who is being sacrificed by decapitation. A stream of blood
pours down into the upturned open jaws of the squatting earth deity.
Blood sacrifice was offered to nourish the earth and to assure the growth
of crops necessary to sustain human life. The pendant was fashioned
from a section of conch shell and worn suspended from the neck (see
illustration, left).
Ethno. 1936 RWB 91

Stone sculpture of female deity *(detail)*
Huaxtec, AD 900 - 1450
H. 136cm x W. 54cm (whole sculpture)
The first Spanish chroniclers give eye-witness accounts of spectacular fan-shaped headdresses made of brilliantly coloured feathers. Skulls and other images of death are frequently found at the back of similar sculptures. These allude to the earth's capacity for devouring the dead who, interred within the body of the earth, then become the ancestral sources of life.
Ethno. Q 92 Am 2.1

Facing page
Limestone figure of an old man and boy
Huaxtec, AD 900 - 1450
H. 34cm x D. 34cm
The wrinkled features and stooping posture of this old man suggest that he represents the aged Huaxtec thunder god 'Mam'. He appears to be engaged in the act of presenting a young boy, perhaps prior to his induction into a peer group. Other versions of the old man show him holding a serpent staff or dibble stick used to penetrate the earth so that it can receive new seed. Similar sculptures are still used today as the focus of ceremonial life in remote rural villages. At planting time they are bedecked with greenery and flowers and people entreat them to ensure the fertility of their fields and a bountiful harvest.
Ethno. 1985 Am 30.1

Pottery vessel in the form of a turtle being
Huaxtec, AD 900 - 1450
H. 21.5cm x W. 22cm
Turtles, being amphibians, offer an apt metaphor for the first emergence of earth from the primordial sea (see stone altar relief from Veracruz, p. 29). Other vessels in this genre show half-animal, half-human composite beings whose deeds figure in creation myths and are still remembered in indigenous folklore and dance.
Ethno. 1936 RWB 1

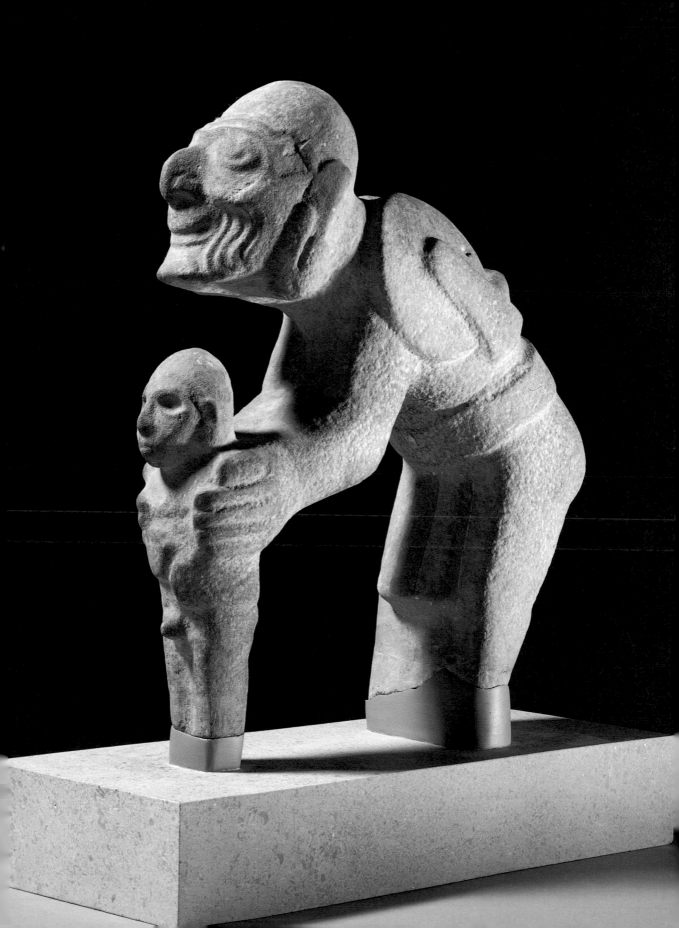

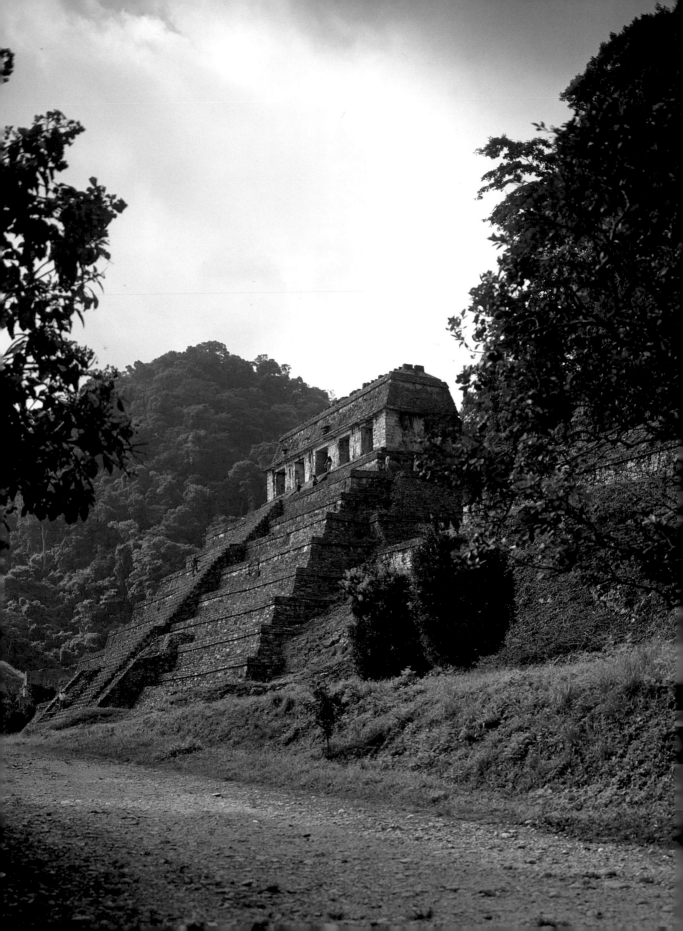

Stucco portrait of Maya noble
Maya, AD 400 - 800
H. 13.4cm x W. 11cm
Three-dimensional heads modelled in stucco, such as this example from Palenque, were incorporated into elaborate architectural sculpture on temple façades and stairways and were once painted in polychrome.
Given by Alfred P. Maudslay
Ethno. 1898.2-18.9

Maya

(250 BC – AD 1000)

Since its rediscovery in the nineteenth century, Maya art and architecture has elicited admiration as the most accomplished of all Amerindian civilisations. Its beginnings can be traced back to the first millennium BC at archaeological sites in Mexico, Guatemala, Belize and Honduras. By the early centuries AD, sophisticated farming systems supported large populations, leading to the growth of Classic Maya city-states ruled by competing dynastic lineages. The invention of hieroglyphic writing allowed the recording of names, birth dates, marriage alliances, royal coronations, wars and the deaths of ruling lords. Detailed texts and figural scenes were inscribed in stone lintels and stelae and incorporated into the architectural fabric of temples, palaces and tombs. The inscriptions place major historical events within repeated cycles of time using a complex and precise calendrical system. The Maya believed that the world had been created and destroyed at least three times and that the last cycle of creation began on 13 August 3114 BC.

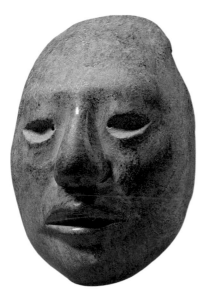

Jade portrait head with inscribed glyphs on reverse
Maya, AD 600 - 800
H. 14.8cm x W. 10cm
The wearing of portrait heads suspended from waist belts or adorning headdresses was the prerogative of members of the ruling lineage (see pp 41 and 44). Although this head was found near Copan, it bears an inscription on its reverse naming a lord from Palenque. It has been suggested that since the mother of Yax-Pac, the last king of Copan, was from Palenque, it is possible that she brought the belt to Copan at the time of her marriage.
Given by A. W. Franks
Ethno. 9599

Facing page **Temple of the Inscriptions, Palenque**
Temples were erected as memorial tombs by Maya kings to commemorate their earthly accomplishments. This building is dedicated to the ruler Pakal ('Lord Shield') who reigned over the kingdom of Palenque from AD 615 to 683 and was interred in a carved sarcophagus placed in a subterranean chamber deep beneath the structure.

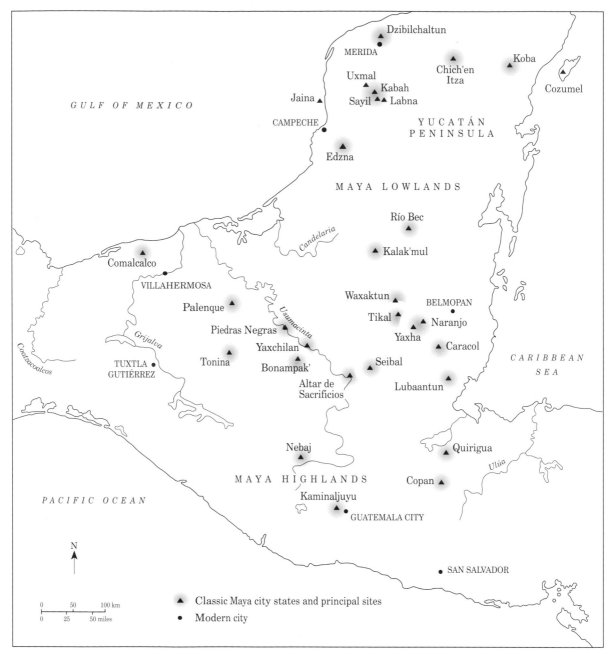

CLASSIC MAYA

Amerindian languages use a range of consonants and vowels that frequently differ from European languages and have often been inaccurately rendered in written form. Here we have adopted a uniform alphabet recently developed with native speakers and applied this to Maya site names. We have, however, retained the conventional hispanicised spelling of geographical terms which are in widespread use, e.g. the Yucatan Peninsula.

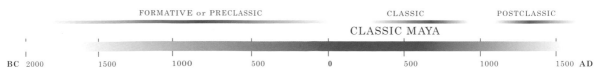

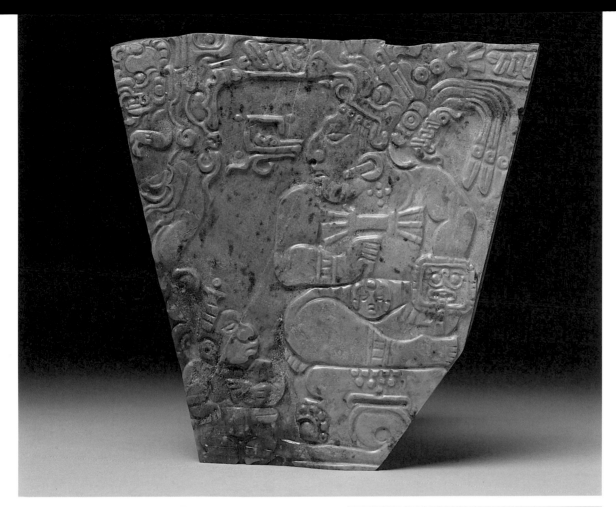

Jade plaque showing a seated king and palace dwarf
Maya, AD 600 - 800
H. 14cm x W. 14cm

This Maya king sits cross-legged atop a raised stone throne. His regal accoutrements include a plumed zoomorphic headdress, jade ear spools, bar pectoral and a royal belt. On his left arm he wears a war shield bearing the image of the Jaguar God of the Underworld. The speech scroll issuing from his mouth perhaps indicates the declaration of a formal edict. Below stands an attendant dwarf - part of a courtly entourage that would have comprised scribes, musicians, artisans and a retinue of lords and ladies. The plaque was found at Teotihuacan, apparently taken there from one of the Classic Maya cities.

Bequeathed by Thomas Gann
Ethno. 1938.10-21.25

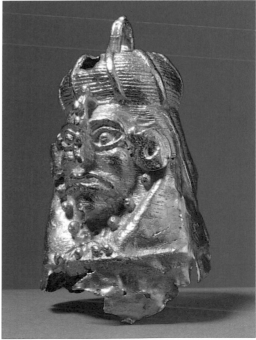

Miniature portrait in gold
Maya, AD 400 - 800
H. 4.5cm

This miniature portrait of a turbaned Maya noble may have been a bell worn as an appendage to a splendid costume.

Given by C.B.O. Clarke
Ethno. 1920-118

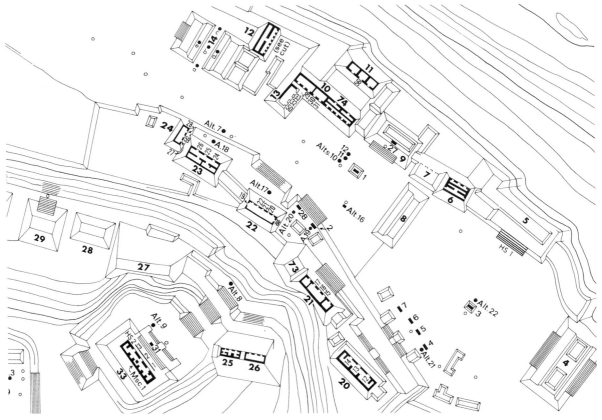

SITE PLAN OF YAXCHILAN

Yaxchilan

Yaxchilan is located on the banks of the
Usumacinta River, close to the present border
between Mexico and Guatemala. The city was
constructed in phases between AD 400 and
AD 800 by successive rulers, among them Lord
Shield Jaguar and his son Lord Bird Jaguar, who
reigned during the seventh and eighth
centuries AD. The plan above shows the central
architectural complexes, including Structures
23 and 21 which housed the two sets of stone
lintel panels illustrated on the following pages.

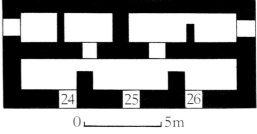

Plan of Structure 23 showing the original
locations of lintels 24, 25 and 26 above the
doorways (see pp 44-5).

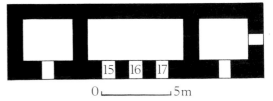

Plan of Structure 21 showing the original
locations of lintels 15, 16 and 17 above the
doorways (see pp 46-7).

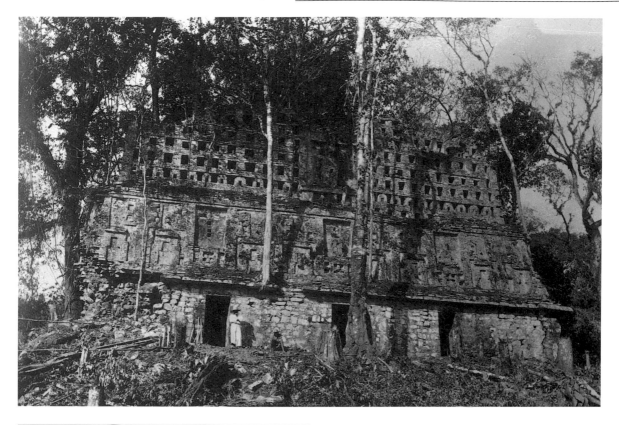

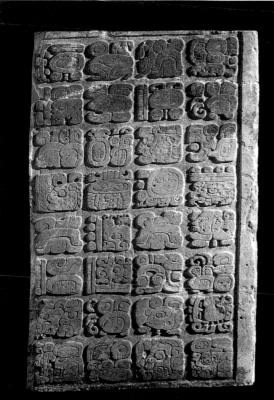

Structure 33, Yaxchilan

The photograph was taken about 1882 by Alfred P. Maudslay. Like most of the principal temples at Yaxchilan, Structure 33 has three doorways with carved lintels. Maudslay's meticulous recording of Maya monuments and glyphic texts at this and other major Maya sites marks the beginning of scholarly studies of Maya civilisation.

Lintel 35

Maya, *c.* AD 450 - 550
H. 100cm x W. 65cm

This is one of eight lintels from Structure 12 which together list nine generations of rulers at Yaxchilan. The lineage culminates in the accession date of 9.5.2.10 6 1 *cimi* 14 *muan* (14 January AD 537) for Lord Mah K'ina Skull 11, also known as Ruler 10. The lintels date from early in the Yaxchilan sequence and it has been suggested that Lord Bird Jaguar IV, the principal protagonist in lintels 15, 16 and 17 (see pp 46-7), had Structure 12 built over two centuries later to house the lintels recording the history of his ancestors.

Ethno. 1886-319

The Yaxchilan Lintels

Two sets of limestone lintel panels are illustrated on this and the following double page spread. The panels commemorate the accession rituals and military accomplishments of two rulers, father and son, at Yaxchilan. The scenes carved in relief on each panel depict the solemn ritual preparations required to invoke the presence of powerful ancestral spirits, ensure success in battle and secure captives for sacrifice. The first set were commissioned by Lord Shield Jaguar and record the rituals commemorating his accession to the throne in AD 681. Shield Jaguar died in AD 742. His son Lord Bird Jaguar succeeded him ten years later and emulated his father's accomplishments by commissioning a new programme of architectural construction including the second set of lintels. Both sets of lintels follow the order in which they were originally placed above the doorways of Structures 23 and 21. Each panel formed the upper lintel of a doorway, so that ritual participants passed directly beneath them. They illustrate particular moments in ritual sequences which were re-enacted on many different occasions and demanded the utmost fortitude from the participants. The accompanying glyphic texts give the dates for specific rituals and name the rulers who performed them.

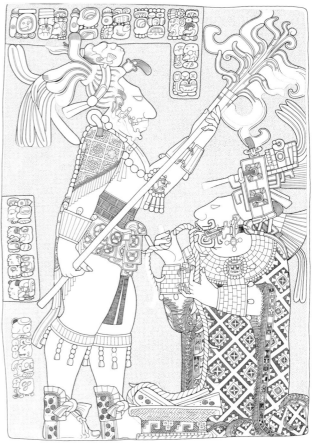

Lintel 24
Maya, *c.* AD 725
H. 109.7cm x W. 77.3cm

This scene depicts Lord Shield Jaguar and his principal wife Lady Xoc engaged in a bloodletting rite that took place on 9.13.17.15.12 5 *eb* 15 *mac* in the Maya calendar, or 28 October AD 709. The king stands on the left brandishing a long flaming torch to illuminate the drama that is about to unfold. Kneeling in front of him wearing an exquisitely woven *huipil*, Lady Xoc pulls a thorn-lined rope through her tongue. The rope falls onto a woven basket holding blood-soaked strips of paper cloth.
Ethno. 1886-317

Glyph for Shield Jaguar

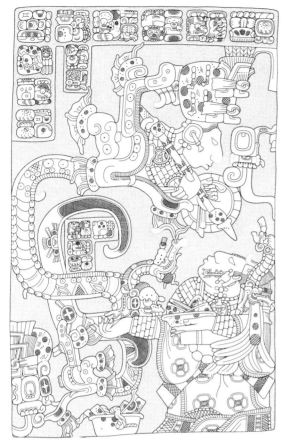

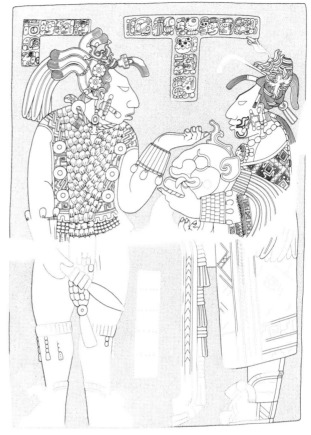

Lintel 25
Maya, *c.* AD 725
H. 129.5cm x W. 85.7cm

The sacrificial offering of blood conjures up a visionary manifestation of Yat-Balam, founding ancestor of the dynasty of Yaxchilan. In the guise of a warrior grasping a spear and shield, this ancestral spirit emerges from the gaping front jaws of a huge double-headed serpent rearing above Lady Xoc. Now alone, she gazes upward at the apparition she has brought forth. In her left hand she bears a blood-letting bowl containing other instruments of sacrifice, a sting-ray spine and an obsidian lancet.

Ethno. 1886-316

Lintel 26
Maya, *c.* AD 725
H. 100.7cm x W. 100.6cm
Museo Nacional de Antropología e Historia, Mexico City

The ritual sequence concludes with one of Lord Shield Jaguar's wives presenting him with his battle garb, including a jaguar headdress which she cradles in her left arm. Her face is still smeared with blood, presumably from a sacrifice like the one depicted on lintel 24. He wears a protective mantle of quilted cotton and wields a hafted knife in his right hand. The glyphic text records that this particular presentation took place on 9.14.12.6.12, or 12 February AD 724.

Glyph for Bird Jaguar

Glyph for Yaxchilan

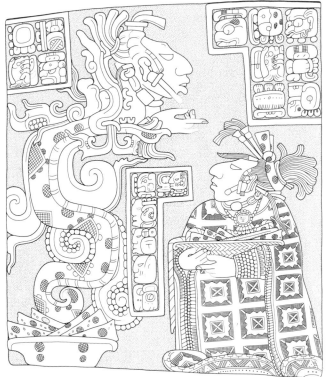

Lintel 15

Maya, AD 770

H. 87.5cm x W. 82.2cm

The three lintels from Yaxchilan Structure 21 record Lord Bird Jaguar's enactment of the ritual depicted in lintels 24, 25 and 26, although they were arranged in a different order. This lintel repeats the vision stage of the bloodletting shown on lintel 25. The serpent coils up through a beaded blood scroll and from its mouth emerges the ancestor the lady has contacted in the rite.

Ethno. 1886-314

Lintel 16

(see facing page, above)

Vestiges of red and blue pigment are still visible on the lintel surface.

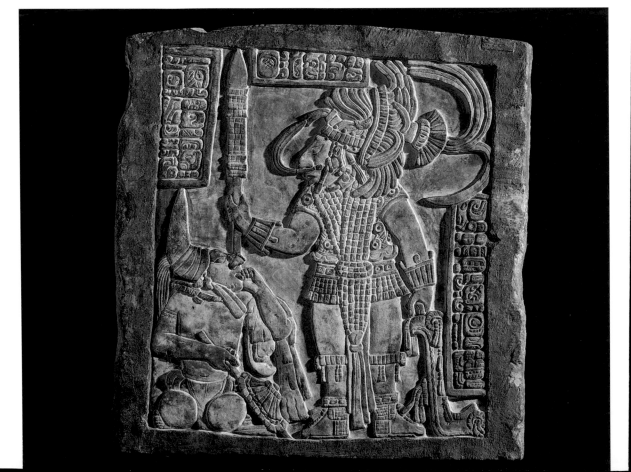

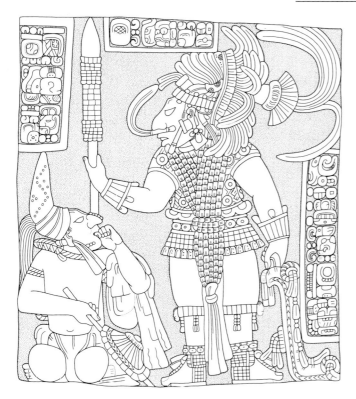

Lintel 16

Maya, c.AD 755 - 770

H. 76.2cm x W. 75.7cm

Here Bird Jaguar stands over a captive noble who, judging from the beaded droplets on his nose and cheek, has already let blood. Eight days later when his heir, Shield Jaguar II, was born, Bird Jaguar and one of his other wives performed ritual bloodletting in celebration. Seventy-five days later, on 3 May AD 752, Bird Jaguar was officially installed as king, an event which took place only after the capture of noble prisoners and, in this case, the birth of a male heir.

Ethno. 1886-318

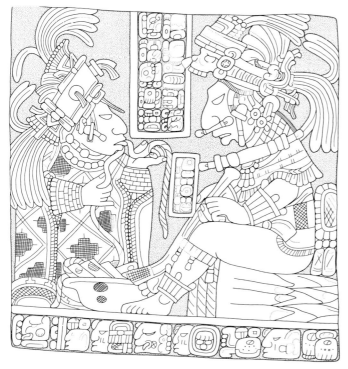

Lintel 17

Maya, AD 770

H. 69.2cm x W. 76.2cm

The bloodletting scene shown here parallels that on lintel 25. The sumptuously dressed kneeling woman pulling the rope through her tongue is Lady Balam-Ix, another of Bird-Jaguar's wives. Opposite her sits Bird Jaguar, also bedecked with ornate earplugs, nosepiece, bar pectoral, jade cylinder cuffs and a shield tied to his back. The fact that he is wearing a skull and skeletal serpent headdress like Lady Xoc on lintel 25 suggests that he too is about to let blood by piercing his penis with the long perforator that he holds in front of him.

Ethno. 1886-320

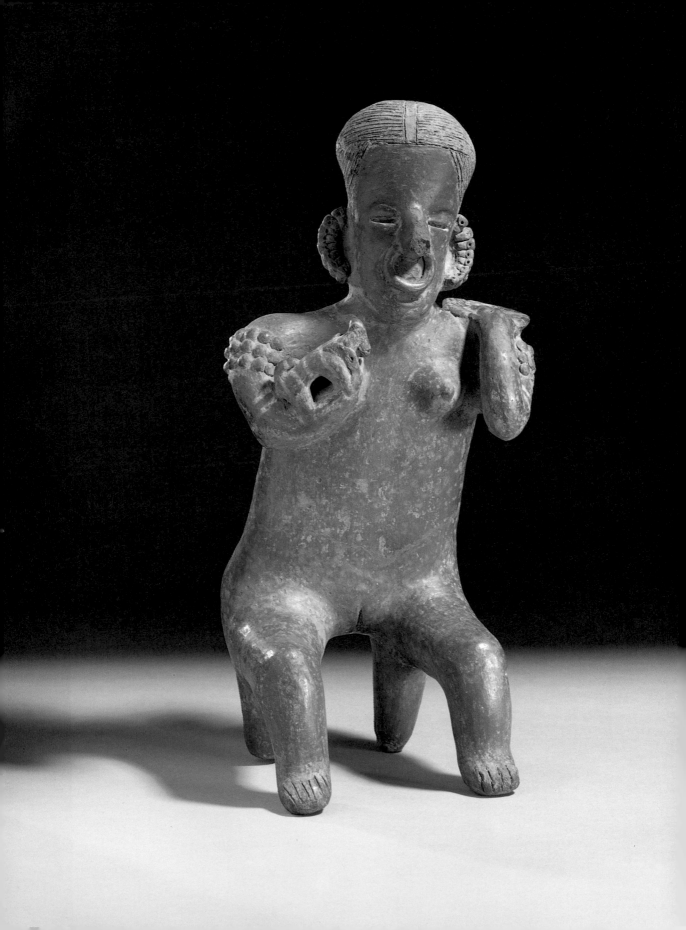

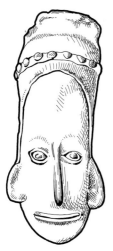

Pottery torso of a female *(detail)*
Jalisco, 300 BC - AD 300
H. 41cm x W. 30cm
West Mexican potters used the plastic properties of the medium to full effect to fashion striking and unusual human images.
Purchased by the Christy Fund
Ethno. Hn. 121

Pottery dog
Colima, 300 BC - AD 300
H. 30.5cm x D. 36cm
A breed of hairless dog (*techichi*) is frequently depicted by Colima artists. Dogs were believed to accompany the souls of the dead on their journey into the underworld and both figurines and dog burials are found in tombs.
Given by E. Rooke
Ethno. 1921.6-13.1

West Mexico

(300 BC – AD 300)

Around 1600 BC a distinctive pottery tradition and tomb form, which have no known antecedents in Mesoamerica, appeared in the western coastal states of Nayarit, Jalisco and Colima. Over a thousand years later this had given rise to an astonishingly diverse range of animated figural sculpture found in deep shaft and chamber tombs similar to tomb forms in Ecuador and Colombia. Just as with the later introduction of metallurgy to West Mexico around AD 600 - 700, ideas and technology seem to have been disseminated by seaborne trade from the south. In the Classic West Mexican art represented by the objects in the British Museum's collections, individual characters and intimate scenes from daily village life are infused with an engaging sense of vitality, humour and realism. Elsewhere, the range of faunal representations includes not only dogs, but also snakes, birds, turtles and marine creatures such as fish and crabs. West Mexican cultures continued to stand apart from the great Classic centres such as Teotihuacan until about AD 800 - 900, when Toltec and Mixtec influences intrude. By the time of the Spanish Conquest an independent Tarascan kingdom ruled much of West Mexico.

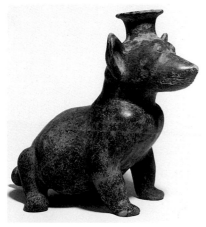

Facing page **Pottery figurine of a woman holding a dog**
Nayarit, 300 BC - AD 300
H. 54cm W. 26cm
This richly-adorned female wears a nose-ring, earrings, necklace and armbands to indicate her high status. With her left hand she holds a plate which rests on her shoulder, and a small dog (see also left) nestles in the crook of her right arm. Her open mouth suggests that she is chanting or singing. The scarification pattern on her shoulders and upper arms was a popular form of body ornament.
Purchased by the Christy Fund
Ethno. Hn.16

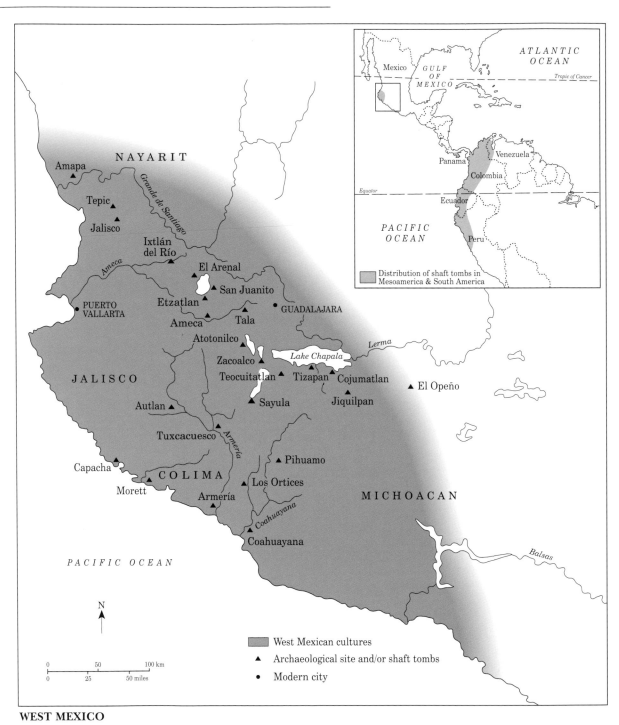

Map labels

NAYARIT

Amapa

Tepic

Jalisco

Ixtlán del Río

El Arenal

San Juanito

Etzatlan

Ameca

Tala

GUADALAJARA

PUERTO VALLARTA

Atotonilco

Lerma

Zacoalco

Lake Chapala

JALISCO

Teocuitatlan

Tizapan

Cojumatlan

El Opeño

Jiquilpan

Autlan

Sayula

Tuxcacuesco

Armería

Pihuamo

Capacha

COLIMA

Los Ortices

Morett

Armería

MICHOACAN

Coahuayana

Coahuayana

Balsas

PACIFIC OCEAN

Grande de Santiago

Ameca

N

0 50 100 km
0 25 50 miles

West Mexican cultures
▲ Archaeological site and/or shaft tombs
● Modern city

Inset map labels

ATLANTIC OCEAN

Mexico

GULF OF MEXICO

Tropic of Cancer

Panama

Venezuela

Colombia

Equator

Ecuador

Peru

PACIFIC OCEAN

Distribution of shaft tombs in Mesoamerica & South America

WEST MEXICO

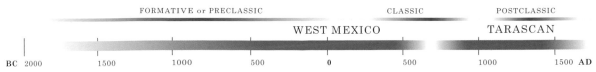

FORMATIVE or PRECLASSIC CLASSIC POSTCLASSIC

WEST MEXICO TARASCAN

BC 2000 1500 1000 500 0 500 1000 1500 AD

Pottery figure of a warrior
Jalisco, 300 BC - AD 300
H. 27cm x W. 14.5cm
Warriors are distinguished by their
protective head-gear and body
armour, probably made of animal
hide stretched over a wooden
frame. Such figures are usually
poised in a formal stance, with
spear at the ready. Their placement
in tombs suggests that they served as
guardians to ward off malevolent
spirits.
Given by L.J.E. Hooper
Ethno. 1949 Am 18.1

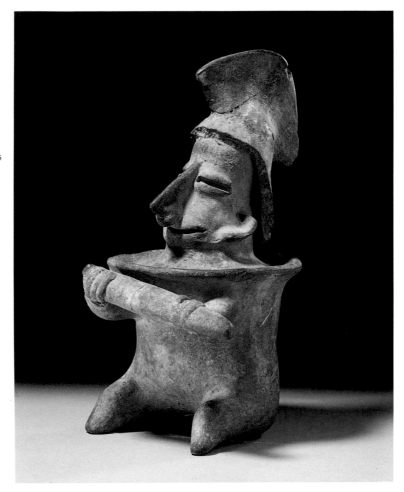

Pottery figure of a drummer
Nayarit, 300 BC - AD 300
H. 23cm x W. 13.5cm
Trumpets, flutes and rattles
combined with the rhythm of
drums to enliven festivals and other
communal celebrations. This
musician boasts a flamboyant
headdress, adornments and
costume. Drumming was also
instrumental in invoking the
presence of ancestral spirits.
Purchased by the Christy Fund
Ethno. Hn. 26

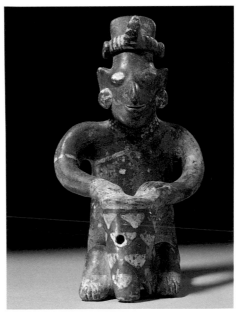

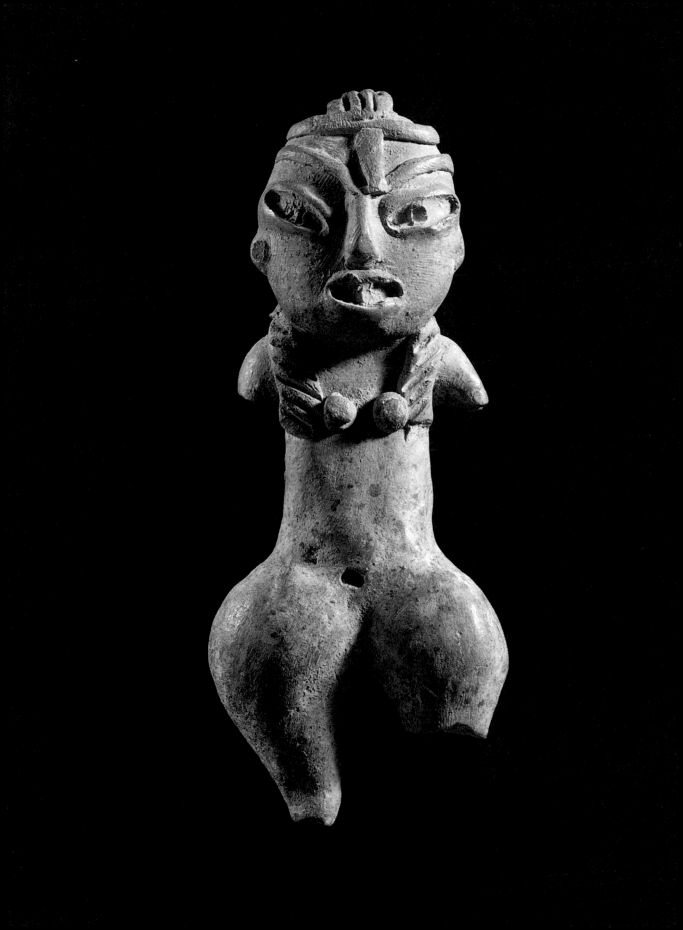

Head of pottery female figurine
Chupicuaro, 1500 - 900 BC
H. 7cm x W. 3.3cm
Typically, Chupicuaro figures have long, diagonally-slanting eyes and incised and appliqué body ornament.
Ethno. 1940 Am 2. 52

Pottery seated female figurine
Tlatilco, 1500 - 900 BC
H. 5.4cm
Although fashioned in miniature, this seated female conveys an intimate and appealing presence.
Given by I. Bullock
Ethno. 1949 Am 13.12

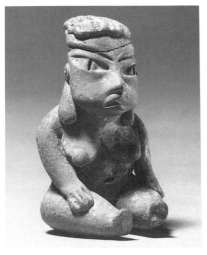

Highland Formative

(1700 – 150 BC)

In the great mountain basin within which lies the Valley of Mexico, highland Formative communities settled in permanent lakeshore villages, adopted agriculture and traded obsidian with neighbouring regions. Artisans honed their wood-working, weaving and lapidary skills, but above all it is the miniature social universe which they created in clay that exerts an enduring fascination. A precocious western pottery tradition may account for the resemblances between West Mexican styles and some early highland Formative vessels and figurines. There are marked contrasts in highland figurine styles ranging from Chupicuaro and Guanajuato area northwest of the Valley of Mexico, to those found at Tlatilco and Tlapacoya in the valley itself. All share an interest in minutely observed and painstakingly detailed human figures, especially females. They are usually found in burials but probably also played a role in household shrines and fertility rituals. By the end of the first millennium BC the central highlands supported a hierarchy of densely-populated towns out of which rose the remarkable urban centre of Teotihuacan (see pp 54-9).

Facing page **Pottery female figurine**
Tlatilco, 1500 - 900 BC
H. 9cm
Most figures stand or sit nude and many have attenuated limbs. However, careful attention is usually paid to details of coiffure and ornament and red or white pigment is often applied after firing. Twin braids hang over the shoulders of this figure.
Ethno. 1956 Am 5.2

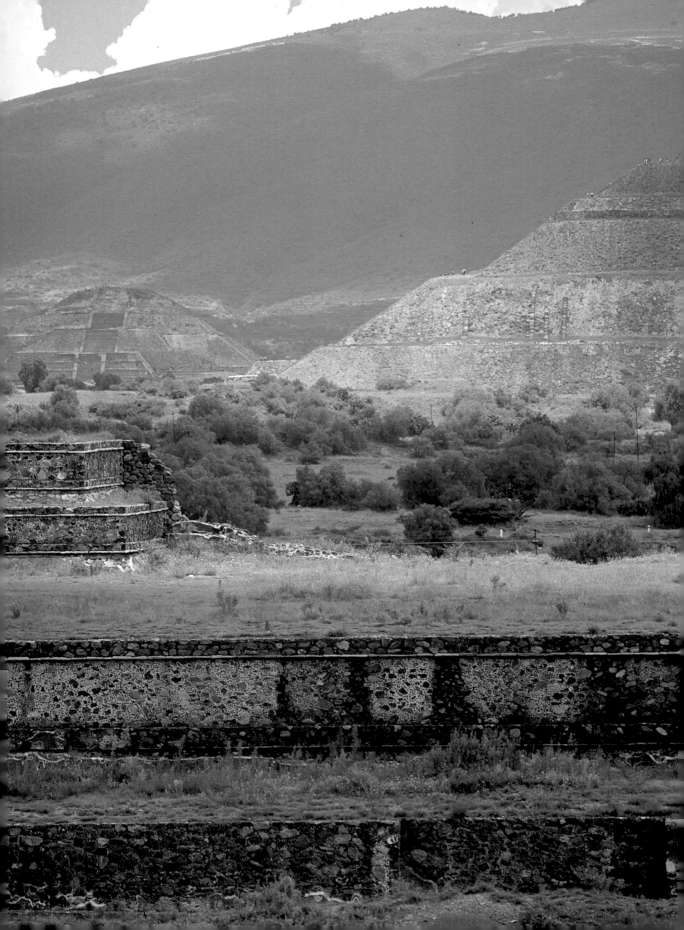

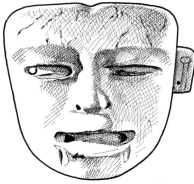

Stone mask *(see photograph p.57)*
Teotihuacan stone masks inherit
elements from earlier traditions.
Here, the cleft head recalls that
found on the Olmec votive axe
(pp 20-21).

**Pottery vessel representing the
Storm God**
Teotihuacan, 150 BC - AD 750
H. 19.5cm x W. 16.5cm
The Water God or Storm God, also
known to the Aztecs as Tlaloc, is
identified by the characteristic
goggle eyes and fangs (see pp 58,
63, 67). Storm gods are frequently
depicted in Teotihuacan mural art
as providers of water, the vital
replenisher of life.
Given by Manuel Gamio, on behalf of the
Government of Mexico
Ethno. 1920.2-16.1

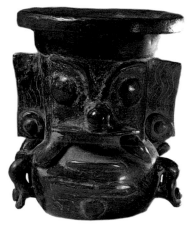

Teotihuacan

(150 BC – AD 750)

By AD 600 Teotihuacan had become a great metropolis
dominating the political, economic and religious life of the
central highlands of Mexico. With over 100,000 inhabitants
it was the largest urban centre in the Americas and the
sixth most populous city in the world at that time. The
formal grid plan which governed the layout of the city was
based on an east-west axis keyed to horizon observations of
the sun and the star constellation known to us as the
Pleiades. An impressive three-mile-long ritual avenue
traversed the city from north to south, leading to the
Pyramid of the Moon. Arrayed on either side of the avenue
were plazas, palace compounds and apartment complexes,
all overshadowed by the imposing bulk of the Pyramid of
the Sun. The surrounding residential quarters supported
enclaves of foreign merchants and artisans from Veracruz
and the Oaxaca Valley, and in return Teotihuacan sent its
own trading and religious emissaries to far-flung sites such
as Matacapan on the Gulf Coast and Kaminaljuyu and Tikal
in Maya territory.

Facing page **Pyramid of the Moon, Teotihuacan**
View towards the Pyramid of the Moon with the profile of the Pyramid of
the Sun to the right and the sacred mountain Cerro Gordo visible in the
background. Teotihuacan has been aptly described as a painted city. A
profusion of splendid, vividly coloured polychrome murals depicting
scenes from ritual processions and mythology once covered wall façades
which now stand bare.

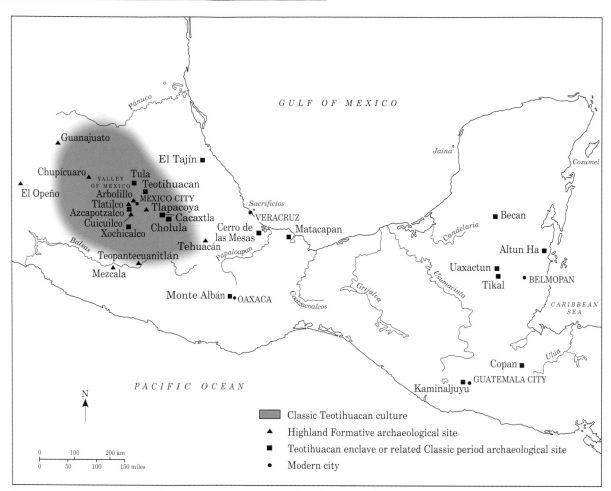

CENTRAL HIGHLAND FORMATIVE AND CLASSIC TEOTIHUACAN

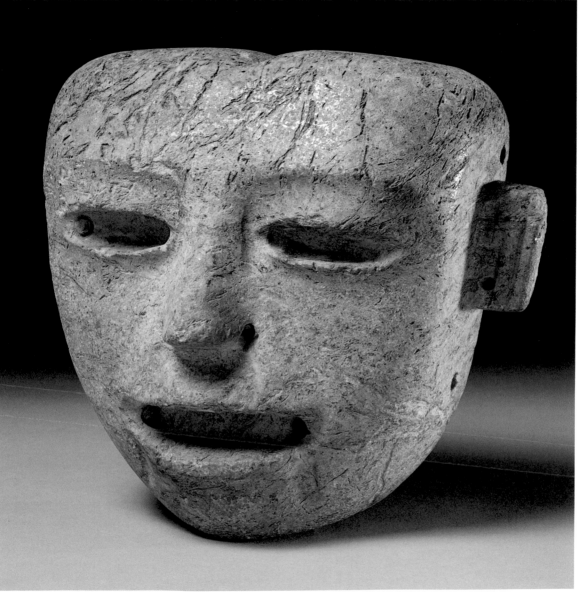

Stone mask
Teotihuacan, 150 BC - AD 750
H. 24cm x W. 26cm
Masks were sculpted in stone that was carefully selected for its visual qualities and symbolic value. Their planar geometry reflects the canons underlying Teotihuacan architecture. Masks range in size from portable objects to massive examples and the eyes and mouths were once inlaid with marine shell, turquoise and polished iron pyrites. They were not intended to be worn, but were most likely mounted on a wooden armature and then dressed with elaborate costumes to embody deified ancestors and gods.
Ethno. Q 94 Am 1

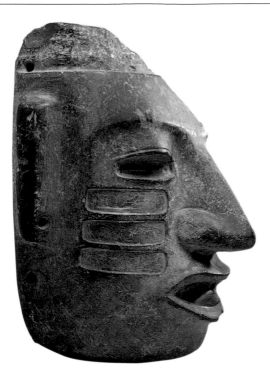

Black limestone mask

Teotihuacan, 150 BC - AD 750
H. 19cm x W. 16.5cm

Some masks show surface detail that probably formed the foundation for inlaid ornament or perhaps represents facial painting.

Given by the Christy Trustees
Ethno. 1940 Am.3.2

Heads of pottery figurines

Teotihuacan, 150 BC - AD 750
H. of tallest 7cm

The strictly-ordered social hierarchy at Teotihuacan is reflected in the great variety of headdresses and costume on small figurines. Miniature representations of major gods, such as Tlaloc, as well as local patron deities can also be recognised.

Given by George Acosta
Top row left to right: Ethno. 1922.11-2.18; 1922.11-2.36; 1922.11-2.37.
Bottom row left to right: Ethno. 1922.11-2.39; 1922.11-2.29; 1922.11-2.34

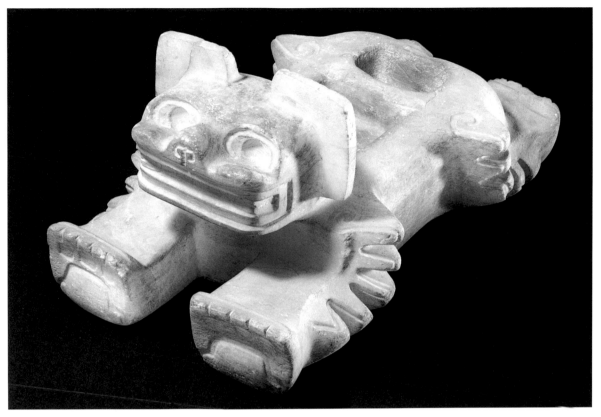

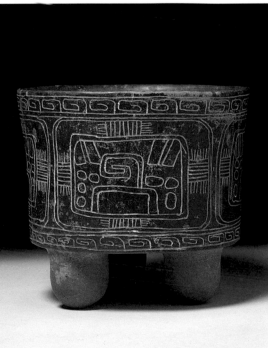

Calcite onyx offering vessel in the form of an ocelot
Teotihuacan, 150 BC - AD 750
H. 16cm x W. 31cm x D. 33.5cm

This unique offering vessel emphasises the planar surfaces and formal geometric elements which are found on many of the stone masks and which impart a distinctive 'corporate' style to Teotihuacan sculpture.

Ethno. 1926-22

Pottery tripod vessel with inscribed glyph
Teotihuacan, 150 BC - AD 750
H. 12.5cm x DIAM. 14cm

Cylindrical tripod vessels are commonly found as funerary offerings in high status burials at Teotihuacan. They carry a wealth of iconographic detail executed in a variety of techniques: incision, excised designs and painted stucco. The incised sign which is repeated four times around the circumference of this vessel has been interpreted as a 'reptile eye' glyph and is used in the Late Classic as one of the 20 day names in the 260-day Mesoamerican calendar.

Given by H.C. Churchill
Ethno. 1926.5-1.1

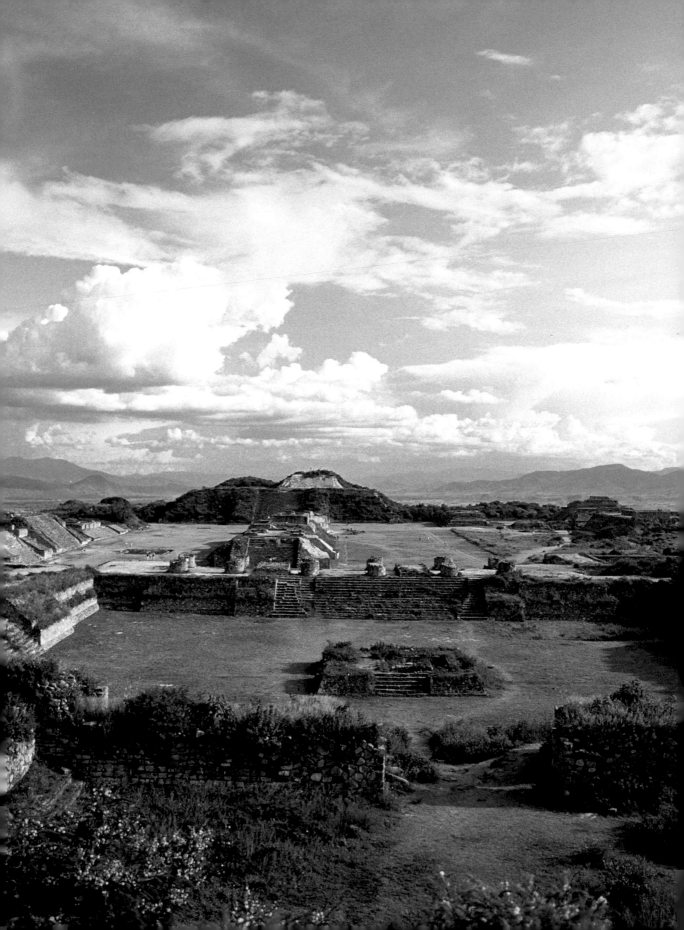

Pottery seated figurine *(detail)*
Zapotec, 200 BC - AD 800
H. 35cm x W. 27cm
Ancestral tombs at Monte Albán
have yielded a great number of
funerary urns and figurines of all
sizes. They feature heavily stylised
costume and ornament.
Ethno. 1849.6-29.20

Pottery figurine
Zapotec, 200 BC - AD 800
H. 32cm x W. 18cm
Elaborately-modelled Zapotec
figures display ornate headdresses
and ear spools according to social
status and role.
Ethno. 1849.6-29.54

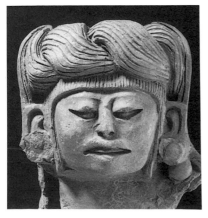

Zapotec

(200 BC – AD 800)

Paralleling the rise of Teotihuacan, Zapotec civilisation flourished in the southern highlands. In the course of the first millennium BC, the early chiefdoms of the Oaxaca Valley coalesced into an expansionist, militaristic state. Around 200 BC the Zapotecs began to construct the first major public architecture at their capital Monte Albán. From this strategically located administrative and ceremonial centre they controlled long distance trading ties with Classic Veracruz cultures to the east, Pacific littoral peoples to the west and Teotihuacan to the north. Zapotec scribes invented one of the four independent Mesoamerican writing systems (the others being Maya, Mixtec and Aztec) and refined their own variant of the 260-day ritual calendar which was in widespread use throughout Mesoamerica. The earliest Zapotec hieroglyphic texts accompany depictions of slain enemies and captives and link rulers to battlefield victories, noble ancestors and supernatural beings. Deceased lords were interred in subterranean tombs in close proximity to the ceremonial plaza. A magnificent masonry ball-court and astronomically aligned structures are incorporated into the architecture of the site.

Facing page **Monte Albán, Oaxaca**
The Zapotec capital, Monte Albán, stands on a commanding hill-top site. The buildings flanking the central plaza were once stuccoed and beautifully painted. Rows of engraved stelae around the perimeter bear scenes recording vanquished and humiliated enemy captives.

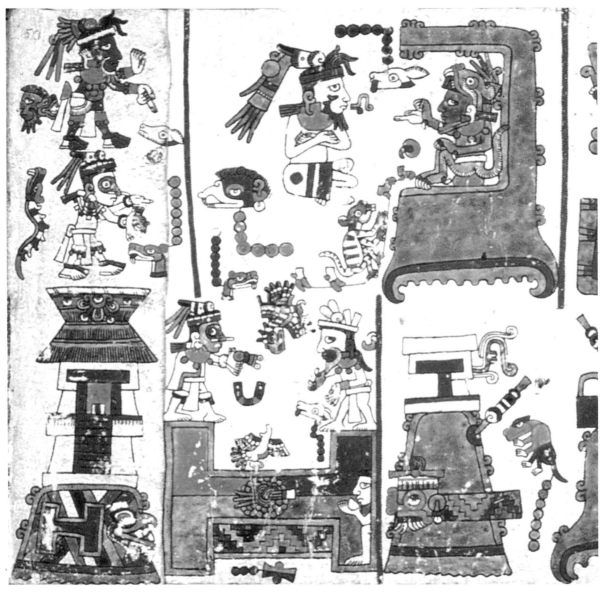

Codex Zouche-Nuttall
Mixtec, AD 1200 - 1521
This is a scene from one of the rare surviving examples of a Mixtec codex. Vivid, highly stylised two-dimensional images painted upon deerskin record the dynastic histories and oral traditions of ancient towns such as Tilantongo. A central figure is the ruler 8 Deer, seen here top right gambling for the town of Tutupec, identified by its place glyph at bottom left. In the foreground is an I-shaped ball-court. The ball game was used as a means of negotiating and resolving political and territorial disputes.

Ethno. 1902.3-8.1

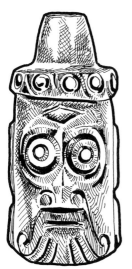

Jade figurine representing Tlaloc
(detail)
Mixtec, AD 1200 - 1521
H. 11.8cm
The goggle eyes, moustache and
protruding fangs identify this as a
representation of Tlaloc, the Rain
God.
Ethno. 1940 Am 2.40

Mixtec

(AD 1200 – 1521)

In mountainous northern Oaxaca, Mixtec peoples founded a distinctive regional culture. Around AD 1200 they began to assert growing power through conquest and political alliances reinforced by marriage, eventually assuming control of Monte Albán and other Zapotec sites. Intense competition existed among rival lords to secure prestige by acquiring territory and wealth. Knowledge of metallurgy, which had been introduced a few centuries earlier from South and Central America, was employed in the production of copper and gold objects to reflect rank and status. Mixtec scribes mastered the art of painting polychrome screenfold books known as codices made of deerskin or bark paper. Access to writing was restricted to the ruling élite, being used to trace genealogical pedigree and to manipulate dynastic history so that historical events were tailored to conform to auspicious mythological and astronomical phenomena. During the fifteenth century AD the Mixtec resisted the Aztec imperial advance; nevertheless the consummate stone-working and metalworking skills of many Mixtec artisans were redeployed in service to the Aztec kings.

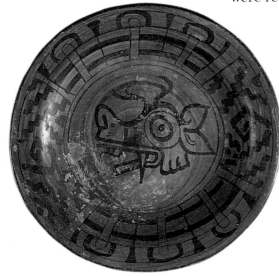

Pottery plate with deer glyph
Cholula, AD 1300 - 1521
DIAM. 20.2cm
The gracefully-painted glyph of a deer on this Cholula plate is executed in a style similar to that found in the Mixtec codices.
Given by F. Ducane Godman
Ethno. 1892.11-9.3

GULF OF MEXICO

■ Cholula

VERACRUZ ●

Papaloapan

HUAJUAPAN ●
■ Quiotepec
Coixtlahuaca ■
■ Cuicatlan

Coatzacoalcos

Yucuñudahui ■
Tzilacayoapan ■
Yanhuitlán ■
■ Nochixtlán

▲ San José Mogote

Tilantongo ■
Monte
Albán
OAXACA
Monte Negro ■
Cuilapan
▲ Yagul
Zaachila
◲ Mitla
Dainzú ▲
Matatlan

Atoyac

Ixtayutlan ■
Sola
deVega

Verde

Jamiltepec ■

■ Tututepec

Pochutlan ▲

Sipilote

N

PACIFIC OCEAN

| Oaxacan cultures
▲ Zapotec archaeological site
■ Mixtec archaeological site and influence
◲ Zapotec site with later Mixtec occupation
● Modern city

0 50 100 km
0 25 50 miles

ZAPOTEC AND MIXTEC

FORMATIVE or PRECLASSIC CLASSIC POSTCLASSIC

ZAPOTEC MIXTEC

BC 2000 1500 1000 500 0 500 1000 1500 AD

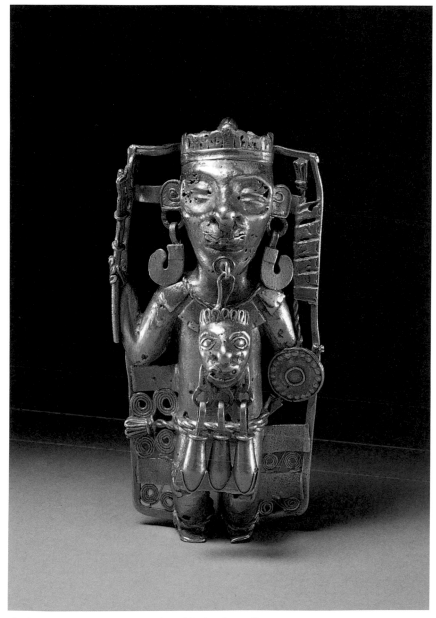

Gold pendant depicting a ruler with ritual regalia
Mixtec, AD 1200 - 1521
H. 8cm x W. 4.5cm

Mixtec metalsmiths fashioned gold into prestigious objects that signalled their owners' status in life and at death accompanied them as tomb offerings. Claims to hereditary nobility depended upon tracing ancestral lineage and proclaiming military prowess in dress and ornament. This ruler, richly adorned with headdress, necklace and earrings, bears a serpent staff and shield and displays a mask suspended from a lip plug.

Purchased by the Christy Fund
Ethno. +7834

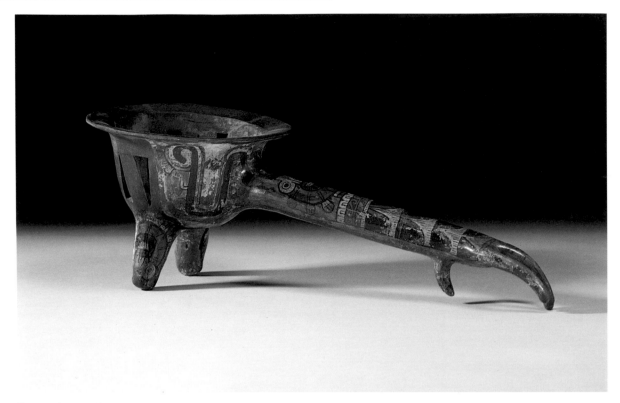

Pottery incense burner

Mixtec, AD 1200 - 1521

H. 20cm x L. 56cm

Long-handled censers were used to make ritual offerings of burning incense. This striking example bears several images of an obsidian mirror, the key symbol which identifies the deity Texcatlipoca (see p. 75). The hollow shaft also functions as a rattle.

Given by Lady Webster
Ethno. 1856.4-22.90

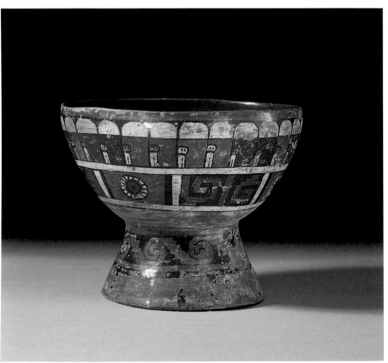

Pottery vessel

Cholula, AD 1300 - 1521

H. 13.2cm x W. 16.3cm

Mixtec stylistic influences are apparent in the polychrome geometric patterns and 'step and wave' motifs on this vessel from the Postclassic centre of Cholula.

Given by F. Ducane Godman
Ethno. 1892.6-18.3

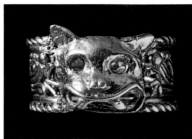

Gold ring with feline head in relief
Mixtec, AD 1200 - 1521
H. 1.1cm
Finely-wrought zoomorphic images reflected the qualities and attributes of the wearer. Powerful felines were seen as intermediaries between the supernatural and mundane worlds and widely used as emblems of authority and rank (see pp 32-3).
Given by Miss Thornton
Ethno. 1914 3-28.1

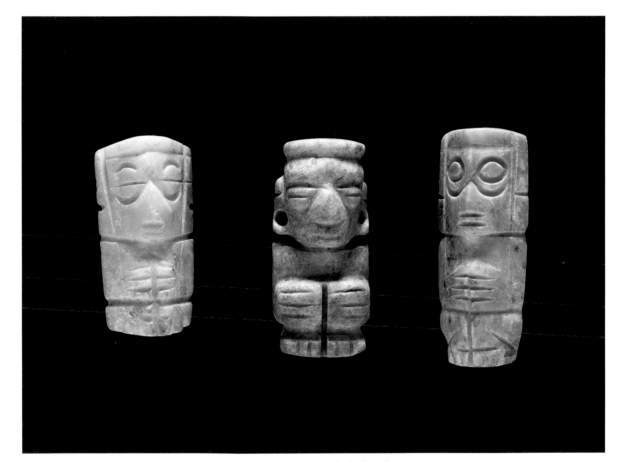

Jade figurines
Mixtec, AD 1200 - 1521
H. of tallest 5.5cm
Small carvings of seated figures with their arms folded across their knees were used as personal amulets or talismans. They are usually made in a variety of greenstone and often depict the Rain God, Tlaloc.
Given by Mrs Alec Tweedie
From left: Ethno. 1926.12-4.16, 1926.12-4.18, 1926.12-4.7

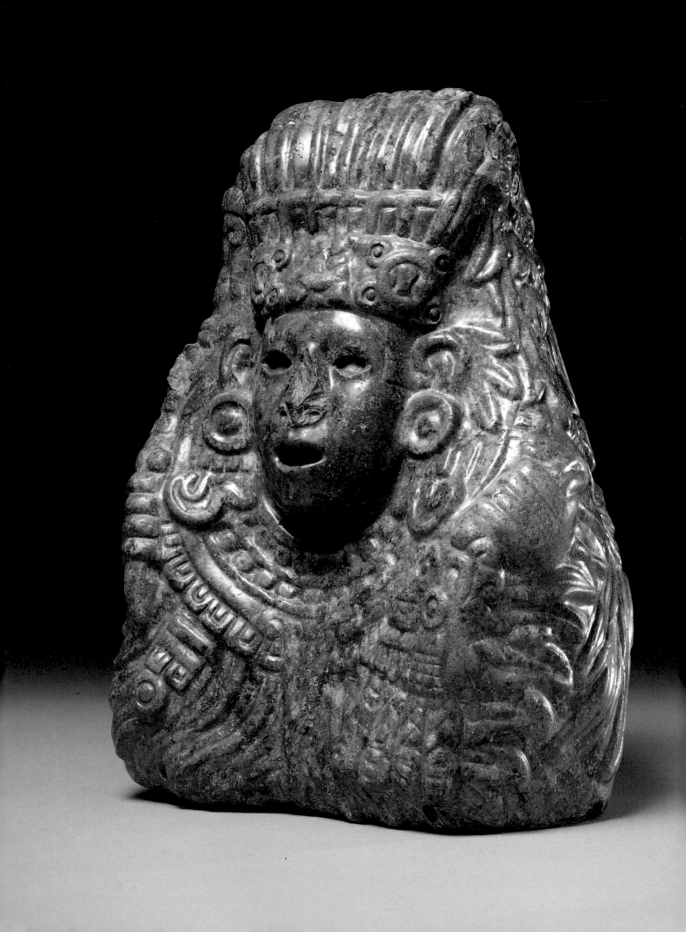

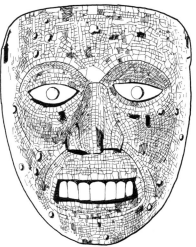

Turquoise mosaic ritual mask
(See pp 70-71)
The Aztec royal court commissioned skilled Mixtec artisans to produce lapidary work of the highest order, notably mosaic masterpieces.

Rattlesnake
Aztec, AD 1300 - 1521
H. 36cm x DIAM. 53cm
This realistic depiction of a rattlesnake (*Crotalus durissus*) accurately records many important anatomical details, including the fangs and bifurcated tongue, suggesting that the reptile's life cycle and habits were closely observed.
Ethno. 1849.6-29.1

Aztec

(AD 1300 – 1521)

The term Aztec has been used since early colonial times to refer to the indigenous peoples settled around Lake Texcoco in the Valley of Mexico. Most powerful among these was the ethnic group known as the Mexica, from whom comes the name for modern Mexico. The Aztecs ruled from the island metropolis of Tenochtitlan which, by the fifteenth century, formed the heart of an empire that embraced much of non-Maya Mesoamerica. Drawing consciously upon their awareness of earlier civilisations and sites such as Teotihuacan and the Toltec capital Tula, the Aztecs forged an imperial dynasty based on military prowess and a network of long-distance trade and tribute that stretched from the Caribbean to the Pacific. Ecological, political and cosmological concerns were woven into a sophisticated ritual calendar reflecting the rhythms of the agricultural year. Human endeavours were held to be part of a larger natural order governed by a pantheon of deities and supernatural beings. At the centre of Tenochtitlan two cult shrines stood atop a large pyramid (Templo Mayor) which had been rebuilt many times. One was dedicated to the ancestral god of war Huitzilopochtli, the other to Tlaloc, the god of rain and renewal.

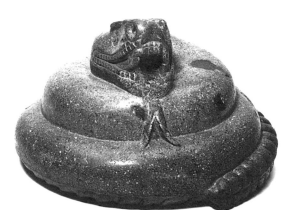

Facing page **Stone bust of Quetzalcoatl**
Aztec, AD 1300 - 1521
H. 32.5cm x W. 23cm
In Nahuatl, Quetzalcoatl means 'quetzal-feather (*quetzalli*) snake (*coatl*)', hence the term 'feathered serpent' for this best known of all Mesoamerican deities. The iridescent green feathers of the quetzal bird were widely used in costume and iconography to symbolise the verdant sources of life-giving moisture. Here Quetzalcoatl's head, with typical curved shell ear ornaments (*epcololli*) and framed by a necklace in the form of a solar disc, can be seen emerging from the plumed coils of the serpent.
Ethno. 1825.12-10.11

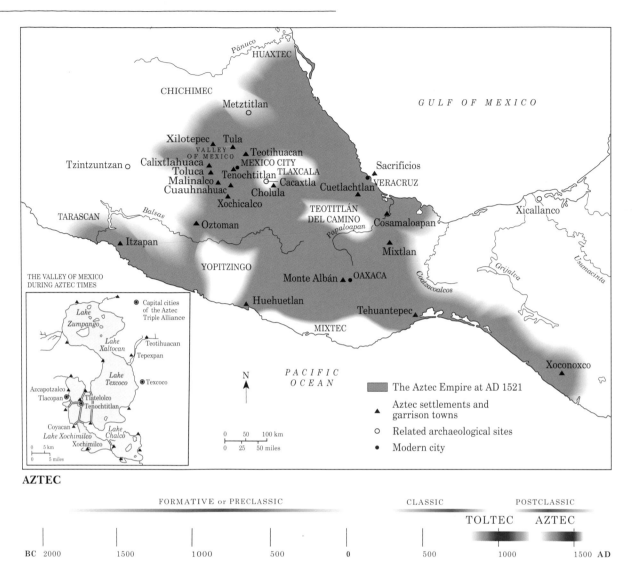

AZTEC

| | FORMATIVE or PRECLASSIC | | | | CLASSIC | POSTCLASSIC |
| | | | | | | TOLTEC AZTEC |

BC 2000 1500 1000 500 0 500 1000 1500 AD

Facing page **Turquoise mosaic ritual mask**
Mixtec-Aztec, AD 1400 - 1521
H. 16.5cm x W. 15.2cm
A stylised butterfly is picked out in mosaic of a darker hue across both cheeks of this mask. The butterfly is an emblem of Xiuhtecuhtli, the central Mexican Fire God (see p. 1), whose name also means Turquoise Lord and who is shown in the codices adorned with turquoise mosaic. Turquoise was among the most highly-valued of all green stones (*chalchihuites*) and was obtained by Aztec trading emissaries (*pochteca*) from mines in what is now the southwest United States, far beyond the limits of the Aztec empire. Special ritual objects and ceremonial regalia including wooden masks, pectorals and shields (see pp 74-6) were inlaid with turquoise, shell, pearl and other precious stones. Masks of the major Aztec deities were probably worn by impersonators to enact scenes from creation myth cycles and to recount the deeds of culture heroes.
Ethno. St.400

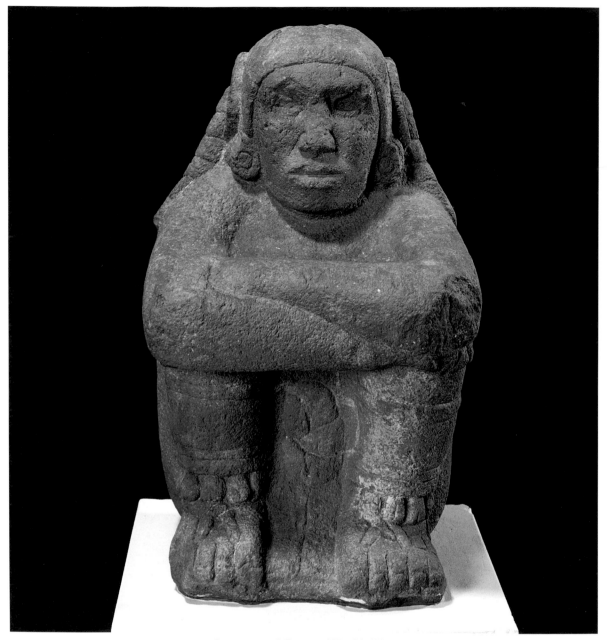

Stone seated figure of Xochipilli
Aztec, AD 1300 - 1521
H. 55cm x W. 32cm
Xochipilli, whose name means 'Flower Prince', was a solar deity and the patron of feasting, music, dancing and poetry. The warm, red colour of the stone selected for this sculpture alludes to his generative powers. He was honoured and fêted early in the growing season; in his negative aspects he punished sins of excess.
Ethno. 1825.12.10.5

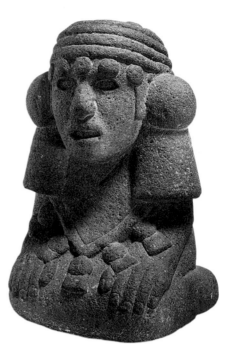

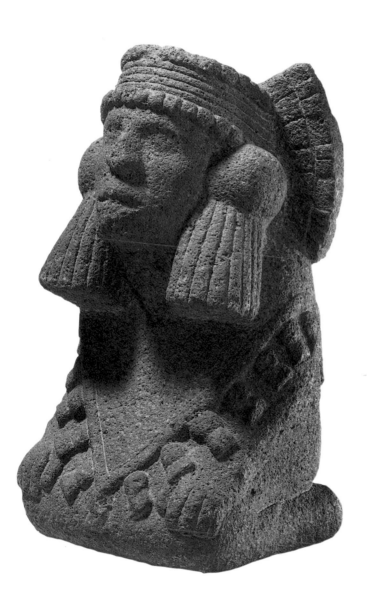

Stone kneeling figures of Chalchiuhtlicue

Aztec, AD 1300 - 1521
(Left) H. 37cm x W. 19.5cm.
(Above) H. 30cm x W. 18cm

The image of the goddess Chalchiuhtlicue ('jade skirt') figures prominently in the codices as a beautiful young woman representing the purity and preciousness of water. She is invariably painted blue, signalling her role in mythology as the wife, mother or sister of Tlaloc, the Rain God. She is associated with spring water used to irrigate the fields and, as the patron saint of fishermen, with lakes and rivers. She also plays an important role in birth ceremonies. Each figure wears a headband adorned with large ear tassels, as well as a tasselled *quechquemitl* (shoulder cape) over a long skirt.

(Left) Ethno. St.373
(Above) Ethno. 1825.12-10.6

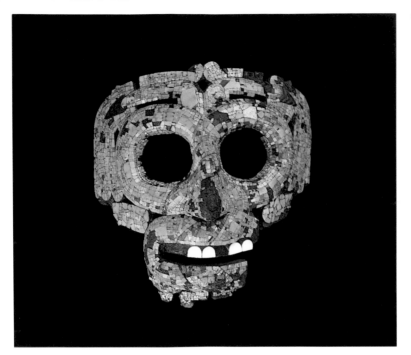

Turquoise mosaic mask of Tlaloc or Quetzalcoatl
Mixtec-Aztec, AD 1400 - 1521
H. 17.3cm x W. 16.7cm
The pair of serpents entwined around the eyes, nose and mouth of this mask (as on the stone head, p. 15) suggest that it may be identified with Tlaloc, or possibly Quetzalcoatl.

Ethno. Q 87 Am.3

Jade eagle warrior
Aztec, AD 1300 - 1521
H. 14.5cm x W. 6cm
Eagle and jaguar warriors were schooled in the arts of war in special precincts in the heart of Tenochtitlan. They earned their status in military orders by performing feats of bravery and daring, notably securing captives for sacrifice. Warriors were awarded insignia, such as cloaks, helmets and shields, according to rank (see shield p. 76).

Given by Lady Webster
Ethno. 1856.4-22.93

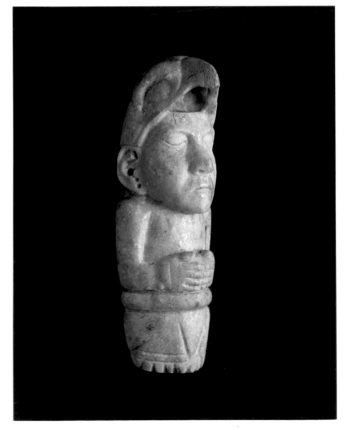

Turquoise mosaic mask of Tezcatlipoca
Mixtec-Aztec, AD 1400 - 1521
H. 19.5cm x W. 12.5cm

A human skull forms the base for this mask of
Tezcatlipoca, 'Smoking Mirror', one of four
powerful creator gods in the Aztec pantheon.
His distinguishing emblem, an obsidian
mirror, symbolises his control over the hidden
forces of creation and destruction. The mask
is decorated with a mosaic of turquoise, lignite
and shell; polished iron pyrites has been used
to fashion the eyes.

Ethno. St.401

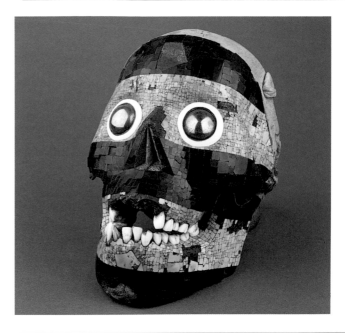

Sandstone seated figure of Mictlantecuhtli
Aztec, AD 1300 - 1521
H. 60cm x W. 27cm

Mictlantecuhtli was the focus of a cult
particularly connected with death. This figure
wears a skull mask and on the shoulder and
back bears the glyphs 2 Skull, 5 Vulture and 4
House, which are likely to be calendrical
names or place glyphs. The sandstone from
which it is made is not found in the Mexican
highlands and was probably obtained in
Veracruz. Coastal sculptural styles seem to
have influenced Aztec sculptors. In the course
of their imperial conquests, the Aztecs also
brought back captured objects and installed
them in their own temples at Tenochtitlan.

Ethno. 1849.6-29.2

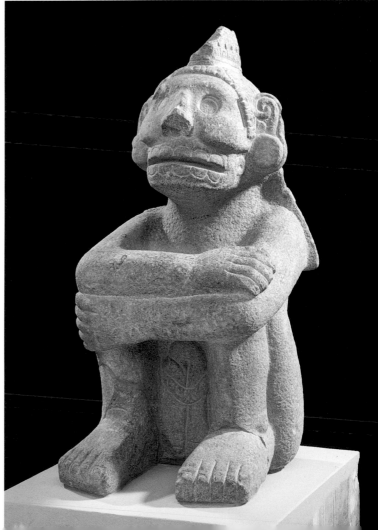

Wooden ceremonial shield with inlay

Aztec, AD 1300 - 1521
DIAM. 31cm

This ceremonial shield bears a design that succinctly portrays the principal divisions of the Aztec universe. It can be looked at in both the horizontal and vertical planes. Viewed horizontally, the circular shape corresponds to the surface of the earth with a navel-like solar disk at its centre. From this extend four rays outlined in red shell dividing the world into four quarters, in each of which stands a sky-bearer. A vertical reading of the design reveals a great serpent emerging from toothed jaws to coil sinuously around a tall tree crowned by flowering branches. The ability of snakes such as constrictors to move freely between water, earth and the forest canopy probably accounts for their symbolic role in Mesoamerican mythology as a mediator between the different vertical layers of the cosmos. The tree-trunk forms a 'world-axis' connecting the underworld, earthly and celestial spheres. At the top an upturned anthropomorphic mask implies that the tree may also be seen as a metaphor for the king, who derives his authority on earth from divine sources of power. The shield was probably adorned with brilliant feathers attached to the holes around its circumference and was reserved for use on special occasions as an emblem signalling the right of the 'warrior-king' to rule.

Ethno. St.397a

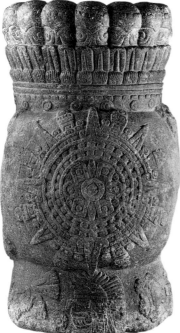

Basalt offering vessel
Aztec, AD 1300 - 1521
H. 56cm x W. 30cm

The chronicles record that *cuauhxicalli* (eagle vessels) served as receptacles for sacrificial offerings and were used in the solemn state ceremonies of investiture and enthronement of new kings. Successive bands of human hearts, feathers and jade encircle the top. The shape of the vessel echoes that of pottery containers used for storing *pulque*. The front bears a solar disk and the glyph 4 Movement, the symbol for the fifth epoch in the Aztec creation cycle. On the base beneath this is the glyph 1 Rain. On the obverse side a symbol for the moon is found together with the glyph 2 Rabbit, one of the calendrical names for the *pulque* god. This opposition expresses a persistent Mesoamerican concern with opposed, complementary forces governing the relationship between natural events and human affairs. The hollow basin on the top of the vessel and some details of the exterior surface were never completed. The object also shows signs of having been intentionally defaced, particularly at the sides. This suggests that an unexpected event, perhaps the arrival of the Spanish, intervened before it could be finished.

Purchased by the Christy Fund
Ethno. +6185

Basalt Calendar Stone
Aztec, AD 1300 - 1521
DIAM. 360cm
Museo Nacional de Antropología, Mexico City

In this simplified rendering of the Calendar Stone, the solar disk and glyph 4 Movement stand at the centre, as on the vessel above, and the four world directions repeat the design on the ceremonial shield (see facing page). A pair of fire serpents with emergent heads framed in their jaws encircle the whole design and meet at the bottom (see p. 11).

Bibliography

SELECTED BIBLIOGRAPHY
A selection of standard reference works in English and a concise guide to recent publications on Mexican archaeology, ethnohistory and ethnography is given below. Many of these cite a wider range of contemporary scholarly publications, invaluable earlier sources, including the published chronicles and codices, and much important material in Spanish. Among current academic journals reporting new research are *Ancient Mesoamerica, Latin American Antiquity* and the *Journal of Latin American Lore.*

GENERAL REFERENCE
Aveni, Anthony F. *Skywatchers of Ancient Mexico.* Austin: University of Texas Press, 1980.
Benson, Elizabeth P., ed. *Mesoamerican Sites and World Views.* Washington: Dumbarton Oaks, 1981.
Brotherston, Gordon. *Painted Books of Mexico.* London: British Museum Press (in press).
Carrasco, Davíd. *Religions of Mesoamerica: Cosmovision and Ceremonial Centers.* San Francisco: Harper & Row, 1990.
Chase, Diane Z. & Arlen F. Chase, eds. *Mesoamerican Elites: An Archaeological Assessment.* Norman and London: University of Oklahoma Press, 1992.
Coe, Michael D. *Mexico - from the Olmecs to the Aztecs.* 4th edn., London and New York: Thames and Hudson, 1994.
Coe, Michael D & Elizabeth P. Benson, eds. *The Atlas of Ancient America.* Oxford: Equinox Ltd., 1986.
Gercke, Peter & Ulrich Schmidt, eds. *From Coast to Coast: Precolumbian Sculptures from Mesoamerica.* (exh. cat.) Verlag Weber & Weidemeyer Kassel, 1992.
Handbook of Middle American Indians. (HMAI). 16 vols and 4 supplements. Austin: University of Texas Press, 1965 - present.
Kubler, George. *Art and Architecture of Ancient America.* 3rd edn. Harmondsworth and Baltimore: Penguin, 1984.
Leyenar, Ted J.J. & Lee Parsons. *Ulama: the Ballgame of the Maya and the Aztecs.* Leiden: Spruyt, Van Mantgem & De Does, 1988.
Marcus, Joyce. *Mesoamerican Writing Systems: Propaganda, Myth and History in Four Ancient Civilizations.* Princeton: Princeton University Press, 1992.
Miller, Mary Ellen. *The Art of Mesoamerica from Olmec to Aztec.* London and New York: Thames and Hudson, World of Art series, 1986.
Miller, Mary Ellen & Karl Taube. *The Gods and Symbols of Ancient Mexico and the Maya: An Illustrated Dictionary of Mesoamerican Religion.* London and New York: Thames and Hudson, 1993.
Scarborough, Vernon L. & David R. Wilcox, eds. *The Mesoamerican Ballgame.* Tucson: The University of Arizona Press, 1991.
Taube, Karl. *Aztec and Maya Myths.* London: British Museum Press, 1993.
The Art of Ancient Mexico (exh. cat.) London: South Bank Centre, 1992.
Townsend, Richard F., ed. *The Ancient Americas: Art from Sacred Landscapes.* Chicago: The Art Institute of Chicago, 1992.
Willey, Gordon R. *An Introduction to American Archaeology: North and Middle America.* vol. 1. New Jersey: Prentice-Hall, Inc., 1966.

OLMEC
Coe, Michael D, and Diehl, Richard A. *In the Land of the Olmec: The Archaeology of San Lorenzo Tenochtitlán.* 2 vols. Austin and London: University of Texas Press, 1980.
Grove, David C. *Ancient Chalcatzingo.* Austin: University of Texas Press, 1987.
Sharer, Robert J. and David C. Grove. *Regional Perspectives on the Olmec.* Cambridge: Cambridge University Press, 1989.

CLASSIC VERACRUZ
Kampen, Michael E. *The Sculptures of El Tajín, Veracruz, Mexico.* Gainesville: University of Florida Press, 1972.
Wilkerson, S. Jeffrey K. 'El Tajín: Great Center of the Northeast' in *Mexico: Splendors of Thirty Centuries* (exh. cat.), New York: Metropolitan Museum of Art, 1990.
Wilkerson, S. Jeffrey K. 'In Search of the Mountain of Foam: Human Sacrifice in Eastern Mesoamerica' in Boone, Elizabeth, ed. *Ritual Human Sacrifice in Mesoamerica.* Washington D.C.: Dumbarton Oaks, 1970.

ISLA DE SACRIFICIOS
Nuttall, Zelia. 'The Island of Sacrificios' in *American Anthropologist*, vol. 12, no. 2. April-June, 1910, pp 257-95.
du Solier, Wilfrido. 'A Reconnaissance on Isla de Sacrificios, Veracruz, Mexico' in *Notes on Middle American Archaeology and Ethnology*, vol. 1, no. 14 Washington, D. C.: Carnegie Institute, 1943.
Medellín Zenil, Alfonso. *Exploraciones en la Isla de Sacrificios.* Instituto Nacional de Antropología e Historia (INHA) Jalapa, 1945.

HUAXTEC
De la Fuente, Beatriz & Nelly Gutierrez Solana. *Escultura Huasteca en Piedra.* Instituto de Investigaciones Estéticas, Universidad Autónoma de México, 1980.
Stresser-Péan, Guy, ed. 'La Huasteca et la Frontière Nord-Est de la Mesoamérique' in *Actes du XLII Congrés International des Américanistes*, vol. IX-B, Paris: 1976, pp. 9-155.

MAYA
Aveni, Anthony F. *The Sky in Mayan Literature.* Oxford University Press, 1992.
Coe, Michael D. *Breaking the Maya Code.* London & New York: Thames and Hudson, 1992.
Freidel, David, Linda Schele and Joy Parker. *Maya Cosmos: Three Thousand Years on the Shaman's Path.* New York: William Morrow and Co., Inc., 1993.
Graham, Ian and Eric Von Euw. *Corpus of Maya Hieroglyphic Inscriptions.* 3 vols. Cambridge, Mass.: Peabody Museum of Archaeology and Ethnology, 1977.
Hammond, Norman & Gordon R. Willey. *Maya Archaeology and Ethnohistory.* Austin: University of Texas Press, 1979.
Houston, Stephen D. *Maya Glyphs.* London: British Museum Publications, 1989.
Sabloff, Jeremy A. & John S. Henderson, eds. *Lowland Maya Civilization in the Eighth Century A.D.* Washington: Dumbarton Oaks, 1993.
Schele, Linda & Mary Ellen Miller. *The Blood of Kings: Dynasty and Ritual in Maya Art.* New York: George Braziller, Inc., in association with the Kimbell Art Museum, Fort Worth, 1986.
Tate, Carolyn. *Yaxchilan: The design of a Maya ceremonial city.* Austin: University of Texas Press, 1992.

Tedlock, Barbara. *Time and the Highland Maya.* Albuquerque: University of New Mexico Press, 1982.
Tedlock, Dennis, trans. *Popol Vuh.* New York: Simon and Schuster, 1985.

WEST MEXICO
Bell, Betty, ed. *Archaeology of West Mexico.* Jalisco: Sociedad de Estudios Avanzados del Occidente de Mexico, 1974.
Furst, Peter T. 'Art of the Ancestors: Archaeology and Symbolism of West Mexico Shaft Tombs and Mortuary Sculpture' in Nancy L. Kalker, ed. *America Before Columbus,* San Antonio: San Antonio Association, 1985, pp.15-46.
Hosler, Dorothy. 'Ancient West Mexican Metallurgy: South and Central American Origins and West Mexican Transformations' in *American Anthropologist,* 90, pp 832-55, 1988.
Kan, Michael, Clement Meighan and H. B. Nicholson. *Sculpture of Ancient West Mexico.* 2nd edn. Los Angeles County Museum in association with University of New Mexico Press, 1989.

TEOTIHUACAN
Berlo, Janet C., ed. *Art, Ideology and the City of Teotihuacan.* Washington D.C.: Dumbarton Oaks, 1992.
Berrin, Kathleen, ed. *Feathered Serpents and Flowering Trees: Reconstructing the Murals at Teotihuacan.* San Francisco: The Fine Arts Museums of San Francisco, 1988.
Berrin, Kathleen and Esther Pasztory, eds. *Teotihuacan: Art from the City of the Gods.* San Francisco, New York and London: Thames and Hudson, 1993

ZAPOTEC & MIXTEC
Flannery, Kent V. & Joyce Marcus, eds. *The Cloud People: Divergent Evolution in the Zapotec and Mixtec Civilizations.* London and New York: Academic Press, Inc., 1983.
Nuttall, Zelia, ed. *The Codex Nuttall: A Picture Manuscript from Ancient Mexico.* The Peabody Museum Facsimile edited by Zelia Nuttall with an introduction by Arthur G. Miller. New York: Dover Publications, Inc., 1975.
Paddock, John, ed. *Ancient Oaxaca.* Palo Alto: Peek Publications 1966.

TOLTEC & AZTEC
Baquedano, Elizabeth. *Aztec Sculpture.* London: British Museum Publications Ltd., 1984.
Boone, Elizabeth H., ed. *The Aztec Templo Mayor.* Washington, D.C.: Dumbarton Oaks, 1987.
Broda, Johanna, Davíd Carrasco, and Eduardo Matos Moctezuma. *The Great Temple of Tenochtitlan: Center and Periphery in the Aztec World.* Berkeley: University of California Press, 1987.
Carmichael, Elizabeth. *Turquoise Mosaics from Mexico.* London: Trustees of the British Museum, 1970.
The Codex Mendoza. Frances F. Berdan and Patricia Rieff Anawalt, eds. Berkeley: University of California Press. 1992.
Diehl, Richard A. *Tula: The Toltec Capital of Ancient Mexico.* London: Thames and Hudson. 1983.
Díaz del Castillo, Bernal. *The True History of the Conquest of New Spain.* Trans. A. P. Maudslay (1908-16), New York, 1958.
Gillespie, Susan D. *The Aztec Kings: The Construction of Rulership in Mexica History.* Tucson: University of Arizona Press, 1989.
Matos Moctezuma, Eduardo. *The Great Temple of the Aztecs.* London: Thames and Hudson, 1988.
Nicholson, Henry B. 'Religion in Pre-Hispanic Central Mexico' in G. Ekholm and I. Bernal, eds. *Handbook of Middle American Indians,* vol. 10, part 1. Austin: University of Texas Press, 1971.
Nicholson, H.B. and Eloise Quiñones Keber. *Art of Aztec Mexico: Treasures of Tenochtitlan.* Washington, D.C.: National Gallery, 1983.
Pasztory, Esther. *Aztec Art.* New York: Harry N. Abrams, 1983.
Portilla, Miguel León. *Aztec Thought and Culture.* Norman: Oklahoma University Press, 1963.
Sahagún, Fray Bernadino de. *Florentine Codex, General History of the Things of New Spain.* Trans. Arthur J. O. Anderson and Charles F. Dibble. Santa Fe and Salt Lake City: School of American Research and University of Utah, 1950-82.
Townsend, Richard F. *The Aztecs.* London: Thames and Hudson, 1992.

Illustration and Photography Acknowledgements

Donors to the Mesoamerican collections are acknowledged in the relevant catalogue entries. Christy's collections were donated to the Museum in 1866 and accessioned in 1883. The major collections that entered the Museum during the nineteenth century illustrated in this catalogue, are listed below. Further information about the provenance of the objects can be obtained from the British Museum Dept. of Ethnography Students Room.

St. Henry Christy Collection
1825.12-10.- William Bullock Collection
1849.6-29.- John Wetherell Collection
1844.7-2.- Capt. Evan Nepean Collection.

p. 9 drawing by Stephen Crummy; p. 18 photo by Colin McEwan; p. 23 drawing of perforator's motifs by Phillip Compton; drawing of facial markings by Meredydd Moores; p. 27 drawing by Stephen Crummy; p. 28 drawing by Meredydd Moores; p. 29 stone relief drawing by Hans Rashbrook after Vernon L. Scarborough and David R. Wilcox, eds, *The Mesoamerican Ballgame,* Univ. Of Arizona Press, 1991, p. 54; drawing of stone panel no. 8 after Kampen, Michael E. *The Sculptures of El Tajín, Veracruz, Mexico,* Univ. of Florida Press, fig. 8a; drawing of Chich'en Itza ball-court marker by Hans Rashbrook; p. 35 drawing of earth deity after *Codex Borgia,* Fondo de Cultura Económica, 1963; p. 38 photo Bob Schalkwijk; p. 42 drawing of site plan by Ian Graham; drawing of Structures 21 and 23 by Hans Rashbrook after Maler, T. *Researches in the Central Portion of the Usumacinta Valley: Memoirs of the Peabody Museum of American Archaeology and Ethnology,* Harvard University, Cambridge, Mass., vol. II, no.2, 1903; p. 43 photo of Structure 33 after Maudslay, A. P. *Biologia Centrali Americana,* ed. Frederic du Cane Godman and Osbert Salvin, London 1880-1902, vol. II, pl. 90; pp 44-7 drawings of lintels by Ian Graham; pp 44-5 glyph drawings from Michael D. Coe, *The Maya,* Thames and Hudson, 1987; p. 55 photo by Bob Schalkwijk; p. 61 section heading drawing by Mike Cobb; p. 76 drawing by Karen Hughes; p. 77 calendar stone drawing by Hans Rashbrook; p. 80 drawing by Hans Rashbrook after *Codex Féjérváry Mayor,* Liverpool Museum; pp 19, 25, 31, 35, 39, 49, 53, 59, 63, 69 section heading drawings by Sue Bird.

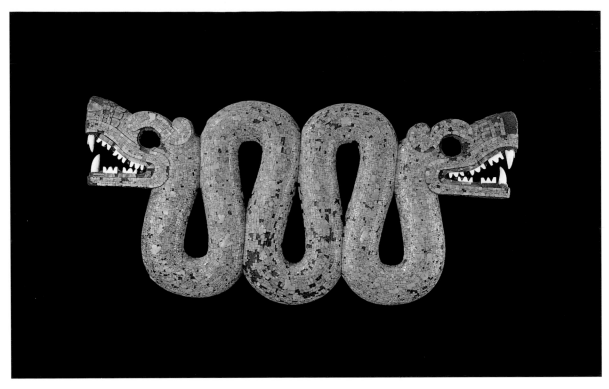

**Turquoise mosaic of
double-headed serpent**
Mixtec-Aztec, AD 1400 - 1521
H. 20.5cm x W. 43.3cm
Double-headed or paired
serpents are an enduring theme
in Mesoamerican mythology and
religion (see pp 29, 74 and 76).
This ceremonial ornament was
perhaps worn on the chest or as
part of a headdress ensemble.
Purchased by the Christy Fund
Ethno.1894-634

Codex Féjérváry-Mayer (detail)
Mixtec-Aztec, AD 1400 - 1521
Liverpool Museum
In a scene from this painted
codex or divinatory almanac, a
black priest makes an offering to
a pair of vertically-entwined
serpents on top of a temple
platform. Certain species of
snake rear up in this manner
momentarily when engaged in
the creative act of copulation.

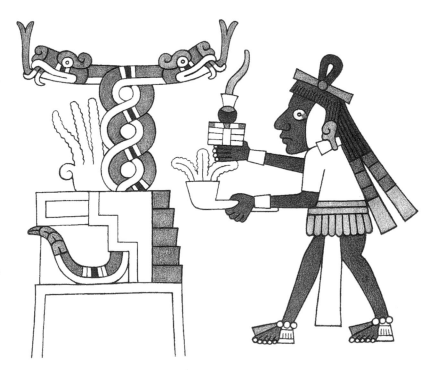